The Art of
Chinese
Calligraphy

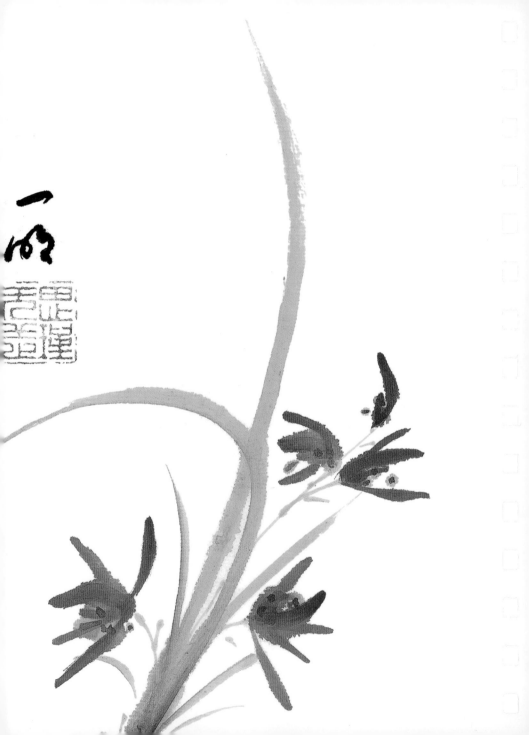

The Art of Chinese Calligraphy

The essential stroke-by-stroke guide to making
over 300 beautiful characters

Yat-Ming Cathy Ho

CHARTWELL
BOOKS

A QUARTO BOOK

This edition published in 2016 by
CHARTWELL BOOKS
an imprint of Book Sales
a division of
Quarto Publishing Group USA Inc.
142 West 36th Street, 4th Floor
New York, New York 10018
USA

ISBN: 978-0-7858-3375-8

Printed by Midas Printing
International Ltd, China

Copyright © 2015 Quarto Inc.
QUAR.OCA

Conceived, designed,
and produced by
Quarto Publishing plc
The Old Brewery
6 Blundell Street
London N7 9BH

Color separation by Modern Age
Repro House Ltd, Hong Kong
Printed by Midas Printing
International Ltd, China

Contents

Introduction

The art of Chinese calligraphy

Chinese calligraphy, or "shu fa," has been highly revered, respected, and loved throughout China's long and proud history. Simply put, calligraphy is a group of characters written with a brush and black ink on a piece of paper; yet the style, shape, and movement of good Chinese calligraphy has an aesthetic significance that matches the importance of art in the East and the West.

As a calligrapher myself, I am totally mesmerized by its beauty, peace, strength, and exuberance, as well as by the demands, frustrations, and hardships that calligraphy brings. When a calligrapher is writing a character or a poem, his/her mind will wander through the past centuries, communicating with the great ancestral calligraphers, planning the construction of the strokes and the characters, as well as contemplating the inner spiritual thoughts, before the tip of the brush touches the paper. It is a vehicle to reach out to our utmost inner spirit.

The rich inheritance of this beautiful art

Chinese calligraphy is unlike any other form of calligraphy in that it has captured the artistic urges of people throughout history. The brush,

the characters, and the ink play important roles in contributing to its unique value.

The different elements in any single character provide opportunities for the artist to explore. The directions and the variety of strokes, the delicate position of each dot and flick, the bold, outstretched duck's tail, and the balancing act that the strokes negotiate with each other have attracted many scholars and artists over thousands of years of Chinese history. The harmonious partnership between the artist's skill and the tools is an important element in this wonderful art. In this book, I have used regular script, or "Kai Shu," for the stroke-by-stroke demonstrations, because this is a clear, modern script that is easy to follow. Where appropriate, I have also shown the character written in running script, or "Xing Shu," with notes on how to modify the strokes.

We are lucky in this era to be able to learn and study previous masters' work and their theories of writing. Their art speaks to you and takes you across the centuries, embracing the whole of Chinese history and its culture.

YAT-MING CATHY HO

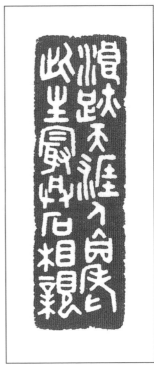

BEAUTIFUL ART
This piece has exuberance and energy.

Getting started

Chapter one

Introduction

Calligraphy is a unique art, closely linked with the lives of Chinese people and far-reaching in its striving for perfection. In this chapter you will learn how to prepare yourself to start practicing Chinese calligraphy, including gathering together the necessary tools and materials and learning, step-by-step, how to make the strokes you will need to construct your characters.

The art of calligraphy is widely popular not just in China, but also in Japan and Korea, where it is promoted and revered as the ultimate scholarly pursuit. The atmosphere is intense, moving, and reverent. It is an art to become totally absorbed in.

The influence of Chinese calligraphy on cultural life in China is much greater than that of Western calligraphy on the Western world. Whether it is the tools, the Chinese characters, or the brushstrokes, the spirit this art instills transcends all explanation and resonates among its practitioners from their earliest experiences of it, prompting many to revisit it in later life.

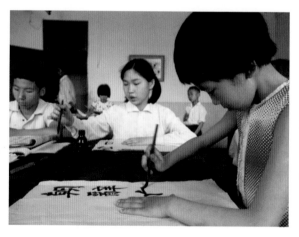

THE STUDY OF CALLIGRAPHY

Children are taught from a young age to love and respect calligraphy—and many grow up hoping to become calligraphers. Schools hold at least one calligraphy lesson a week, and each student will have his or her own box of materials, with a cotton wool pad to contain black liquid ink, a brush, and a book with checked squares for practice.

"The four treasures of a scholar's study"

Paper, brush, ink, and ink stone have long been referred to as "the four treasures in a scholar's study" in Chinese history. All four treasures are made from Chinese natural resources, and have always played an important role in Chinese art and culture.

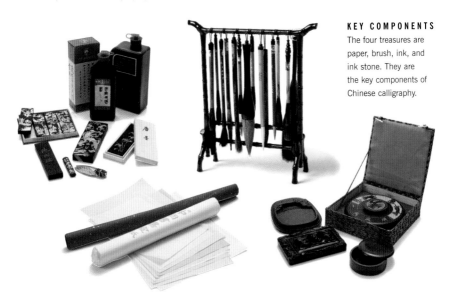

KEY COMPONENTS
The four treasures are paper, brush, ink, and ink stone. They are the key components of Chinese calligraphy.

At the heart of calligraphy is the brushstroke. Calligraphy's beauty, strength, and spirit can be traced along the lines that the brush produces with the help of paper, ink, and ink stone. There is no question that they work in perfect partnership.

The following pages will take you through a brief history of calligraphy and the basic tools and equipment you will need before you begin practicing. This is followed by step-by-step guides to each of the main techniques required to form strokes. Read through this section before starting any of the characters, and refer back to it once you've begun writing characters from the directory (pages 38–231).

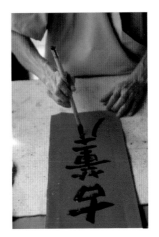

CALLIGRAPHY PRACTICE
People of all ages practice their calligraphy, using red paper for special occasions.

Appreciating Chinese calligraphy

Chinese calligraphy is art; so let us regard it as we would any painting. There are a few criteria essential in appreciating a piece of calligraphy, and they are discussed on these two pages.

STROKES

Are the strokes alive as if they are moving on the paper? Are they executed with variations of thickness and style? Can you see the intrinsic energy ("gu qi") present within the strokes? If you don't detect any of these, the strokes would look lifeless and flat.

THE SOUL, OR "QI"

Chinese calligraphy is the combination of technique and the calligrapher's personal emotional expression. When a calligrapher reaches a certain level, the spontaneity and emotions are woven into the lines. This creates a flowing vibration and energy ("qi") right through to the end. These two characters by Kwan Shut Wong illustrate this beautifully.

HARMONY AND CONTRAST

This variation exists in any art form. We should expect to find harmony and contrast both within any character and in the whole piece of calligraphy.

CHARACTERS

Do they look well balanced, beautiful in shape, and flamboyant in style? Are they written with a sense of continuity, in such a way that they seem to relate to the adjacent characters?

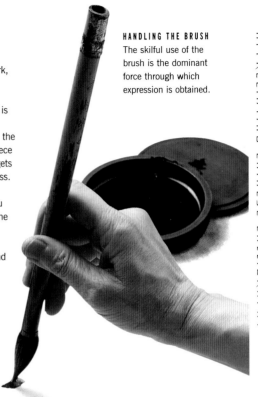

The importance of the required technique

The aesthetic of a piece of calligraphy relies heavily on the technique of the calligrapher, who might spend years in practicing brushwork, studying the many different structures of characters and the methods to convey the thoughts within the lines. All in all, technique is the basic requirement in Chinese calligraphy.

Every dot and stroke should be executed at the right place at the right moment. The whole piece of writing will be ruined if one of the strokes gets too close to another or is not the right thickness. That is why the learning curve can be long, difficult, and frustrating. But soon enough, you will find joy and satisfaction awaiting you at the end of your brushstrokes.

A good piece of calligraphy is one that is moving, intriguing, tantalizing, challenging, and breathtaking. It should touch you deeply.

HANDLING THE BRUSH
The skilful use of the brush is the dominant force through which expression is obtained.

APPRECIATING CHINESE CALLIGRAPHY

CALLIGRAPHY AND ART
There is a close connection between calligraphy and painting, and the author of this piece, Lui Tai, is considered to be an artist. Calligraphy and art share the same basic materials of brush, paper, and ink.

The history and forms of Chinese characters

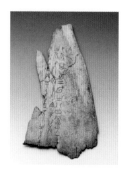

1550 BCE **JIA GU WEN** (BONE AND SHELL WRITING)

Four thousand years ago, picture writing or symbols engraved onto animal bones and tortoise shells were used to provide interaction in daily communications and business transactions. Artifacts discovered during excavations dating back to the Shang-Yin dynasty (1550–1030 BCE) are referred to as "Jia Gu Wen" (Bone and Shell writing). Some engravings were found to have brush marks, which could have been the written symbols before carving.

1030 BCE **ZHONG DING WEN** (BRONZE VESSEL INSCRIPTION) AND **DAI ZHUAN** (GREAT SEAL SCRIPT)

The inscriptions on bronze vessels were a development from bone and shell writing. Bamboo strips were used to record court proceedings; these did not survive with time. The "zhong ding wen" inscriptions, in the form of "Dai Zhuan" (Great Seal Script), have become the sole source for the study of the Zhou dynasty (1030 BCE).

722 BCE **STONE DRUM INSCRIPTION** (GREAT SEAL SCRIPT; SPRING AND AUTUMN PERIOD)

Carved inscriptions in the form of Dai Zhuan (Great Seal Script) on drum-shaped stones gave an important insight into the "Spring and Autumn period" (722–481 BCE), a time when hundreds of scholars voiced their great ideas and philosophy. The most influential ones were Confucius and Lao Zi (Taoism).

221 BCE QIN DYNASTY **XIAO ZHUAN** (SMALL SEAL SCRIPT)

The prime minister Li Si to the emperor of Qin (221–207 BCE) devised Xiao Zhuan (Small Seal Script) and unified the various forms of characters from the Warring State period (480–222 BCE). This was an important step toward the formation of characters.

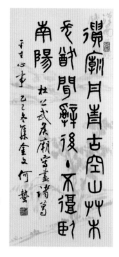

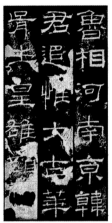

221 BCE QIN DYNASTY LI SHU (CLERICAL SCRIPT)

A Qin prison officer, Cheng Miao, who spent time in jail because of an offense, created another form of character. With the aim to reduce time spent recording court procedures, Li Shu (Clerical Script) was devised to have fewer strokes and has straight lines rather than the rounded shapes of the previous form. It was a bold step toward opening up other styles in calligraphy.

48 BCE CAO SHU (CURSIVE SCRIPT)

Shi You, a scholar in West Han (202 BCE–AD 9), derived from Li Shu a cursive style of characters. It is executed in linked-up strokes, which produce an artistic flowing expression.

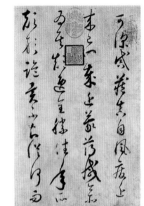

AD 220 WEI KAI SHU (REGULAR SCRIPT)

The first form of Kai Shu was found written on bamboo sticks dating back to the Wei period (AD 220–265). Though this Regular Script was derived from Li Shu, the technique of using the brush is very different.

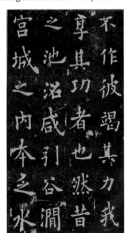

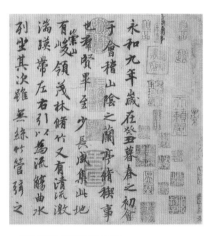

AD 220 LATE HAN XING SHU (RUNNING SCRIPT)

Xing Shu started around AD 220, with a style between Cursive and Regular Script. It is not as formulaic as Regular script, and is less elastic than the Cursive. This is the most popular style that calligraphers like to use. There were many brilliant practitioners of this style; the most famous one was Huang Xi Zhi (AD 317), who was regarded as the saint of calligraphy.

Paper ("zhi")

Paper is one of the greatest inventions of the Chinese people. Until recently, Cai Lun (East Han dynasty, AD 25–221) was credited with its discovery. However, fresh excavations have uncovered paper scrolls dating to the West Han dynasty (202 BCE), much earlier than previously recorded.

Moon Palace paper and
Xuan paper

"Xuan" paper is the predominant type of paper used for modern calligraphy and Chinese painting. This white paper is composed primarily of green sandalwood, straw, bamboo, and bark, giving it a toughness that belies its thin, soft, and absorbent texture.

The three main types of Xuan paper are:
- **Raw Xuan**—Most suitable for painting, this paper is the most absorbent of the three. It is not cut to size.
- **Shu Xuan**—This paper is more suitable for calligraphy as it has a lesser degree of absorbency and has been sized with alum.
- **Semi-raw Xuan**—This paper has also been sized with alum, but remains absorbent.

Papers you can get from suppliers

You can buy Xuan paper, grass paper (Yu Kou Zhi), Moon Palace paper, and red paper (for special occasions) from most art shops. The paper you buy is not prepared to standard sizes, so it is usually necessary to cut it yourself.

Practice Paper

You can use anything that you think is suitable for practice and rough work—from newspapers to wallpaper!

Cactus
paper

Grass paper

Plain wallpaper

Red paper

Mounting

This is an important final step in the presentation of calligraphy. Mounting gives the finished piece of writing a smooth, bright, and lively look, while also enhancing the color. However, the procedure can be laborious, so it is a good idea to mount a few pieces at once to save time.

You will need

- Wallpaper paste
- Two clean, wide brushes
- Clean cloths
- A piece of rod (optional)
- A large bowl
- A water spritzer
- A large smooth surface (e.g. mirror, door, wide board)
- A large table

STEP 1

Mix some wallpaper paste with water—add more water than instructed on the packet because calligraphy paper is thinner than wallpaper. Test the consistency on a scrap of calligraphy paper before using on your final piece.

Use a pencil to mark where you want your border to be, making sure that you leave enough space so as not to cramp the calligraphy.

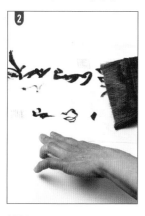

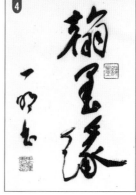

STEP 2

Lay the calligraphy face down on the table. Spray it with just enough water to stop it from moving. Apply the paste to the back of the piece with a wide brush, working from the center outward. Make sure you don't forget the corners.

STEP 3

Carefully lay the second, larger piece of paper on the back of the calligraphy, making sure it is spaced evenly four inches from the top. Brush down with a clean brush to remove any bubbles. Use a dry brush to continue smoothing as much as possible.

STEP 4

After applying paste along all four sides of the border, carefully lift the piece up, using a rod if it is a long piece, and stick the whole piece onto a board with the calligraphy facing outward.

When it is dry (this takes a few days), remove the calligraphy from the board by cutting the edges. The mounted calligraphy will be smoothly stretched and ready to be framed.

Brushes

The Chinese have been using these charming tools for over 4,000 years. The most famous Chinese brushes are made in Hu Zhou in the province of Zhe Jiang. Brushes are traditionally made of animal hair stuffed in a bamboo tube, with each type of hair providing the bristle with a unique texture and stroke. The best brushes for calligraphy beginners are those made of wolf hair, or those made of weasel, rabbit, or mixed hair. Always check the fullness, resilience, and evenness of a brush before purchasing.

The writing on a brush's handle describes the type of hair the brush is made of.

1 Bear-hair brush
This hair of bears is very strong, creating a hard-wearing, and resilient brush.

2 Deer and wolf mixed-hair brush
Deer hair is soft and absorbent. This brush offers the benefit of both types of animal hair.

3 Large goat-hair brush
Goat's hair is soft and absorbent, so it is easy to manipulate between strokes.

4 Large horse-hair brush
This thin-handled brush uses lots of ink. You will need a large ink stone/pot to hold enough ink for just one stroke.

5 Goats'-beard-hair brush
Made of mountain goat hair, this brush is stiff with tremendous energy. It is fantastic for painting.

6 Goat-hair brush
This Hu Zhou soft-haired brush retains more liquid than the hard-haired brushes. It is suitable for both painting and calligraphy.

7 Orchid and bamboo brush
This brush is both resilient and springy. It can be used for both painting and calligraphy.

8 Large mixed-hair brush
Full, pointed, even, and resilient, this tool has all the qualities of a good brush.

9 Purple-hair brush
This Hu Zhou brush is made from wild rabbit hair.

10 Wolf-hair brush
Calligraphers favor this brush because it is strong and full, as well as flexible—useful when negotiating within lines.

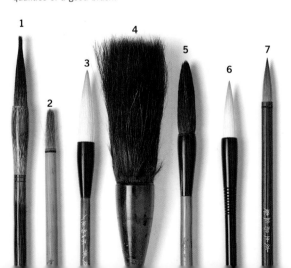

How to care for brushes

New brushes

Remove and discard the lid. Soak in warm water for at least 20 minutes (depending on brush size), until the glue coating the hair has dissolved. Use your fingers to reshape the brush into a point and remove any excess water.

Cleaning brushes

Have a pot of water ready for rinsing. Always clean your brush when you finish writing or when taking a break. More thorough cleaning should be done under a tap, as calligraphy brushes take up lots of ink.

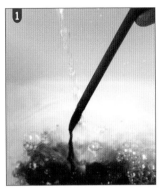

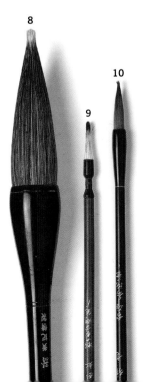

STEP 1

Hold the brush point down under a running tap until the water runs clear. Never run water against the direction of the hairs.

STEP 2

Gently squeeze excess water out of the hair. Smooth and reshape the hair with your fingers. Hang the brush tip down on a brush stand by the little loop on the handle until dry. Then place it in your brush pot with the tip pointing upward. If you don't have a brush stand, you can place the brush (tip up) directly in a brush pot to dry.

8

10

9

HOW TO CHOOSE BRUSHES

The famous Hu Zhou brush makers assert that a good-quality brush is pointed, even, full, and resilient.

POINTED
The tip of the brush should be pointed and centered.

EVEN
When you flatten the tip of the brush with your fingers, the hairs should all be the same length.

FULL
The brush should be substantial, well rounded, and symmetrical, with tightly packed hairs.

RESILIENT
A good brush should be strong, healthy, and durable. Its hair should spring back into place when bent—if a brush remains bent after a stroke, it is too soft.

Ink ("mo")

Chinese ink is made
by mixing the soot
collected from burnt
pine or oil with glue
(traditionally made from
deer horn or animal hides).
Top-quality ink sticks have a clear,
crisp sound when tapped with your
fingers and should be hard and
heavy, with a purple sheen. The
lighter the sheen, the poorer the quality of the
ink. Good ink retains its color for a very long
time and will not spread, even after mounting.

Ink sticks come in
many varieties

Types of ink

Pine oil ink stick—This ink is made
by adding glue to the soot of burnt
pine branches.

Oil ink stick—A rich black ink made by
burning sesame oil over an oil lamp, then
adding glue. As a higher ratio of glue is
used than in any other ink, lots of water
must be used during grinding.

Pine lampblack ink stick—Made by
burning cooking oil and pine branches
over an oil lamp, then adding glue.
The rich, black color has an extra sheen
that makes it suitable for calligraphy.

Bottled ink—There are several
manufactured bottled inks on the market.
Use these to practice with.

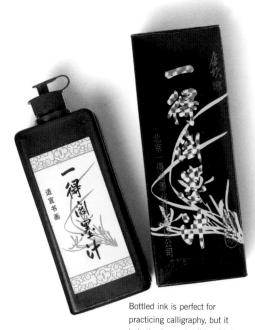

Bottled ink is perfect for
practicing calligraphy, but it
is better to use traditional ink
sticks for final calligraphy pieces.

Ink stone ("yan")

An ink stone is used for grinding ink. It can be made of stone or clay. You need an ink stone with a smooth surface that will not damage your ink stick. It must also be big enough to hold the amount of ink you need for calligraphy. The most famous ink stones are "Duan yan" and "She yan."

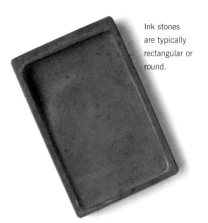

Ink stones are typically rectangular or round.

Making ink

Ink grinding can be the perfect time to contemplate the piece of writing you are about to begin. Follow the steps laid out here to learn how to prepare your ink.

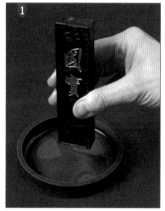

STEP 1

Drip some water (not too much at first) onto the ink stone.

Hold the ink stick upright and use a moderate movement to grind steadily and evenly in one direction. Try not to press too hard on the stone so as not to damage the stone's surface.

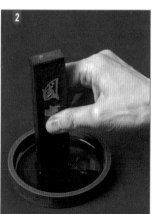

STEP 2

The ink will thicken slightly when it is ready. You can test it on the paper to check the consistency. A good consistency will allow you to lift the brush off the paper without dragging on it. If the ink is too thick, drip in some more water and grind again.

When you are finished using the ink stone, use tissues to wipe off the ink. Rinse it under the tap to remove any excess ink, then dry it.

STEP 3

Pour a little clean water onto the ink stone and put the lid on, ready for next time.

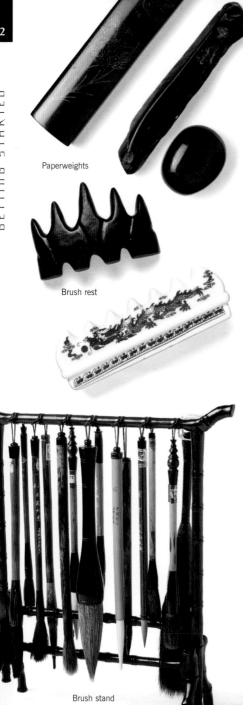

Paperweights

Brush rest

Brush stand

Essential items for calligraphy

In addition to the "four treasures" of paper (pages 16–17), brush (pages 18–19), ink (page 20), and ink stone (page 21), you will need a few other basic supplies.

Tools for paper

Blanket—Use to cover your work table.
Paperweight—Essential when working with Chinese paper, which has a tendency to roll up. Try making one yourself, using pebbles, a long piece of wood, or a decorative pottery slab.

Tools for brushes

Brush stand—Hang brushes on this tip down to dry after cleaning (best practice).
Brush pot—For storing dry brushes with their tips upward.
Brush rest—Use when taking a break from writing to keep brushes from rolling about. They are usually made of metal or ceramic. If you can't find one, a chopstick rest does the trick.
Bamboo mat—For storing brushes when traveling to prevent the tips from getting damaged. You can buy these in any good Chinese supermarket.
Brush wash—Any glass container filled with clean water. For your own convenience, always have one ready when writing.
Water container with a spout—Used to drip water into ink when mixing, or when ink dries out.
Tissue paper—Always have a roll of tissue ready for cleaning purposes.

Mounting
brush

Brush pot

Water
containers

Box containing
cinnabar
paste

Name
seals

NAME SEALS

Consider creating a seal to stamp your
work with. A good calligrapher is always
accompanied by his/her cinnabar paste and
personalized name seal.

SEAL ("YIN ZHANG")

Artists devote a lifetime to the exquisite art
of seal making. Seals can be square, round, oblong,
or irregular in shape. Soapstone is preferred for
seal making, as its softness makes it easy
to engrave.

There are two types of seals: name seals
and leisure seals. Name seals are used as a form
of personal identification on documents, calligraphy, or
paintings to declare either ownership or authorship.
An artist's name seal is normally stamped below
his/her name on a scroll. A leisure seal is a fun seal.
Anything that is dear to you can be engraved on
it, such as a short phrase (e.g., "entwined with the
ink" or "the talents that God endowed me with must be
useful") or a meaningful image (e.g., a dragon or Buddha).
The characters that make up the phrases are engraved on the
seal in Xiao Zhuan (Small Seal Script).

SEAL PAD ("YIN NI")

The red cinnabar paste used to stamp a seal is a
delightful contrast to the black-and-white austerity
of calligraphy—the two complement each
other perfectly.

There are different sizes to choose from—
you obviously need a big pot of cinnabar paste
to accommodate the larger seals.

Always keep the lid on the cinnabar
to prevent it from drying out.

Cinnabar
paste in a ceramic
container

Preparation

Calligraphy is an exercise in mind and movement.
The mundane task of preparing all your materials can
prevent you from setting your mind at ease. Therefore,
if you are serious about the art of calligraphy, it is
a good idea to consider having a table with all your
materials on it set up permanently somewhere.

Arranging equipment for calligraphy

Lay a blanket or cloth over your table in order to absorb any ink that may stain it. Place your equipment (brushes, ink stone, ink, brush rest, and water pot) to your right (or to your left if you are left-handed). Place the paper directly in front of you, with the calligraphy book you are copying from next to it.

Once the equipment is laid out, prepare the ink for writing. The process of ink grinding is calming and can help you to focus. When you are ready, pick up the brush, dip it into the prepared ink, scrape away the excess ink from the side of the ink stone, and focus on what you are about to write or practice.

NURTURING YOUR MIND

EXERCISE FOR THE RIGHT FRAME OF MIND

Calligraphers often practice t'ai chi quan or qi gung (a breathing exercise) before and during writing. These exercises can help focus the mind by nurturing our qi (life force) and developing the vital energy within us. Caring for our qi is fundamental to developing and maintaining the qualities and attitude intrinsic to the composition of beautiful calligraphy.

"ZHAN ZHUANG" (STANDING STANCE)

Practice the standing stance (zhan zhuang) before writing. Stand with your toes hooked slightly inward and your feet shoulder's-width apart. Raise your arms to about waist level with palms facing one another. Keep your elbows relaxed, as if you are holding a ball. Lower your shoulders and bend your knees. Close your eyes and breathe in deeply, drawing your breath down to your "dan tien" (two inches below the navel). Slowly exhale, relaxing your abdomen. When you feel completely relaxed, lower your arms and stand up straight. Try practicing this exercise for two minutes before writing, slowly increasing to five minutes as you improve. Now you are free to contemplate your work while grinding your ink.

The calligrapher's table

Table—Best placed close to a window in order to take full advantage of natural light. If the light is poor, shine a table lamp or a floor light onto your paper. You will achieve better light if you face the light toward the hand that is holding the brush.

Blanket—Cover the table with a blanket to absorb ink from the paper.

Sitting position—You will need to sit comfortably in a chair that allows your feet to touch the floor. You may also find it more comfortable to have a flat cushion on the chair in order to raise your posture. If you are writing large characters with a big brush, it is best to stand up to give yourself more room to maneuver.

Brushes, brush rest, water pot, ink, and ink stone—Should be arranged within easy reach of the calligrapher's writing hand.

Paperweights and paper—Position these in the middle of the table, placing the paper weights on the paper when you start writing. There are no lines to follow on calligraphy paper, so it is best to position the paper straight and directly in front of you. This will enable your eyes to more accurately guide your handwriting.

THE CORRECT SITTING POSITION

There are no lines to guide your writing on Chinese calligraphy paper. The best way to write without losing your line is to make sure that your paper is positioned correctly and that you adapt the proper sitting position. Sit upright with the paper positioned straight in front of you—if your paper is not straight, your writing will become slanted and uneven. "Hang qi" (the qi of lines) is vital in calligraphy.

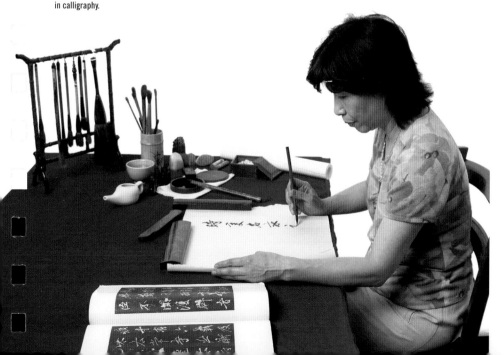

How to hold the brush

The brush is an extension of the calligrapher's hand. Therefore, it is important that you are comfortable and at ease with it. Keep the brush upright most of the time, making sure you are deliberate but flexible in its use. The rounded handle will allow you to turn it when needed. Hold the brush with your fingers only, remembering to leave an empty space between it and your palm. Hold the brush higher when writing big characters and lower for the smaller ones, but never close to the bristle. If you practice every day, any discomfort you may feel in holding the brush will disappear.

Holding a brush

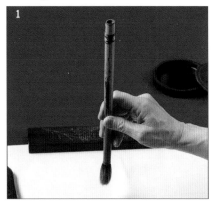

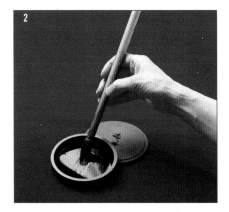

STEP 1
Hold the brush primarily with your thumb and first two fingers, followed by your ring finger. Use your little finger to push it from behind. Keep a gap between your palm and the brush.

STEP 2
Tilt the brush and dip it in the ink, rotating it until the bristles are completely saturated.

THE DIFFERENT WAYS TO HOLD A BRUSH

FOR SMALL CHARACTERS

Use a smaller brush when writing small characters. Hold the brush about one inch from the bristle (no lower). If you wish, you can keep your elbow on the table to steady you, but keep your wrist elevated so that you can move your hand freely.

FOR MEDIUM-SIZED CHARACTERS

Adopt whatever position is comfortable for you—sitting or standing. You may find that standing gives you more freedom of movement. If you opt to sit, practice elevating your elbow off the table while lowering your shoulders—the standing stance breathing exercise is helpful in creating this position, as it relaxes your shoulders and elbows.

FOR BIG CHARACTERS

Big characters require great flexibility of movement, so it is easiest to stand in front of your work. It is best to work on a long table so that you can pull the paper back out of your way while writing. Hold the brush further up the handle until you are confident in controlling the brush. Leave a bigger space between your palm and the brush to allow for more freedom and flexibility. Keep your brush pointed straight down while lowering your shoulders and relaxing your elbow.

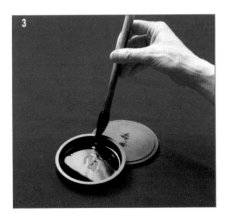

STEP 3

Use the edge of the ink stone to scrape off the excess ink. Keep rotating the brush until the tip is pointed and centered.

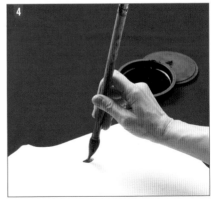

STEP 4

Hold the brush upright above the paper, ready to place the tip for the first stroke.

Writing techniques

Technique is of the utmost importance in Chinese calligraphy. Each time the calligrapher touches brush to paper, the thousands of hairs in the bristle tell the calligrapher whether the strokes should dance, twist, pull, drill swiftly, heavily, lightly, or contemplatively.

The basic techniques in brush-handling are "ti" (lift) and "dun" (press downward). Ti and dun command the control of all movement in the art of calligraphy.

The only way to tackle and master these techniques is to practice—try practicing on newsprint, or rolls of cheap, plain wallpaper.

Ti (lift)

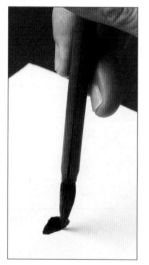 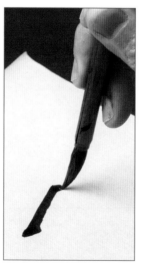 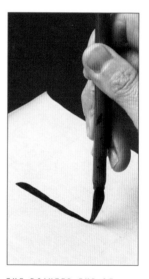

DOT

There is not a single moment in calligraphy where the brush can be allowed to rest on the paper—not even when writing a dot. Pull the tip of the brush from the starting point and then ti (lift) the brush, tucking it underneath the short stroke.

STRAIGHT STROKES

A stroke will be flat and lifeless if you don't ti (lift) your brush when performing a horizontal or vertical stroke. When you near the end of your stroke, lift the brush so that the tip can return to close the stroke.

THE POINTED END OF A STROKE

Whenever a stroke ends in a point, be sure to ti the brush. To achieve the desired effect, you must maintain complete control of the brush until the final point of the stroke is complete.

Dun (press)

This technique involves pressing the brush down without relief while drawing in a continuous movement.

AT THE BEGINNING OF A STROKE

Press the tip of the brush down at the beginning of the stroke, and continue to push down (dun) while pulling the stroke.

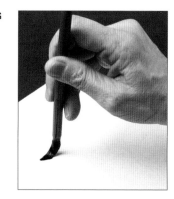

DUCK'S TAIL: DOWNWARD STROKE

Some strokes have a knifelike aspect. Start by loading the brush with ink, then pressing down and pulling the brush down to the "corner" of the duck's tail.

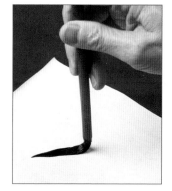

AT THE CORNER

Change direction in a smooth movement, and pull the bristle to the right to form a point.

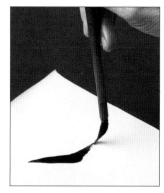

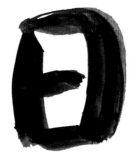

A BAD EXAMPLE OF TI AND DUN

In the character "ri" (sun) above, the calligrapher has not lifted the brush when negotiating the top right corner and the endings of the strokes, leaving them flat and lifeless.

A GOOD EXAMPLE OF TI AND DUN

These two characters ("ri" and "yue" (sun and moon) are lively and joyful, jumping and skipping, using ti and dun to move around the strokes.

Horizontal and vertical strokes

Calligraphic strokes should be crisp, sharp, and energetic, as if chiseled with a knife. How you choose to perform a horizontal or vertical stroke (short, long, heavy, elegant, or slightly slanted) is a matter of personal aesthetics. Nevertheless, practicing the correct form will allow you to execute a stroke however you like in the future.

Horizontal strokes

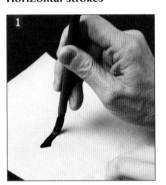

STEP 1

Place the tip of the brush on the paper to begin a horizontal stroke. Pull the brush to the right.

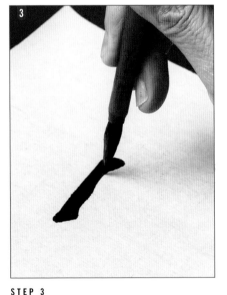

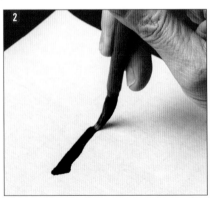

STEP 2

When you near the end of the stroke, lift (ti) the brush slightly.

STEP 3

Continue the movement by pulling the brush to the right, then tucking it in. To do this, complete the movement by returning the brush slightly to the left and closing the stroke.

Vertical strokes

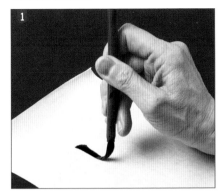

STEP 1
Begin by pointing and pushing the tip of the brush down on the paper at the top left-hand corner of the stroke.

STEP 2
If performing a straight stroke (without a point), pull the brush downward until you near the end of the stroke. Then ti (lift) the brush, returning the tip upward along the stroke.

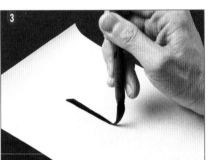

STEP 3
If the stroke ends with a point, carry the brush straight down until near the end of the stroke. Finish by lifting (ti) the brush, gradually pulling it to a point.

Dots

Almost like short strokes, dots contain a number of movements within a small space. A dot is written in the form of a triangle. Practice dots as if they were shortened versions of longer strokes.

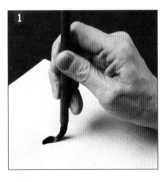

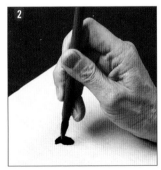

STEP 1
Place the point of the brush on the paper and pull slightly downward and to the right.

STEP 2
Lift (ti) your brush, then tuck it under the stroke by returning its point to the beginning of the dot.

Flicks

Located at the end of a stroke, a flick is usually short and pointed upward. Each stroke is significant to its character (as well as to the entire piece of writing), so put some movement into your flick and deliver your qi right to the end of the stroke.

At the end of a long stroke

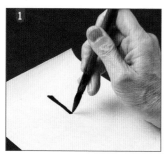

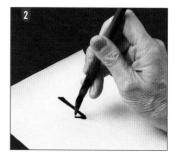

STEP 1
Place the tip of the brush below the long stroke, with the point angled left.

STEP 2
Flick upward to the left or right of the stroke (depending on the character). End with a point. Make sure the flick is chiseled, sharp, and full.

Downward slanting stroke (to the left)

Although it appears rounded, a curve should be executed in short, straight lines to give it a sense of vitality.

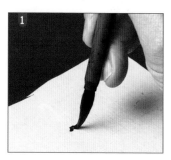

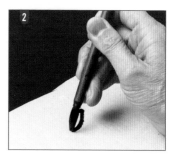

STEP 1
Tuck in the tip of the brush to the left, slanting the brush downward and to the left.

STEP 2
Deliver the stroke to the desired position. If the stroke ends with a point, lift (ti) the brush slightly, gathering the bristle into a point.

Upward slanting stroke (to the right)

This slanting upward stroke moves right and ends in a point. Execute it with vigor. Try to use short, straight strokes for the tilting slant.

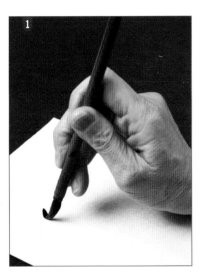

STEP 1

Tuck in the tip of the brush before executing the stroke upward and to the right. The length of the stroke needed depends on the character.

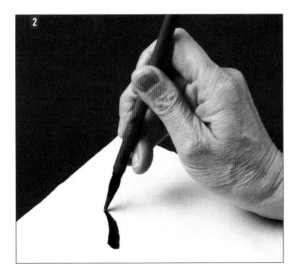

STEP 2

Make sure that the tip of the brush is carried right to the end of the stroke. End with a point.

WRITING TECHNIQUES

Turning corners

Chinese writing has many instances where strokes or flicks are joined to the end of another stroke. Treat them as separate strokes by lifting your brush after the first stroke and then beginning the second stroke at the corner. They should look sharp and chiseled.

Joining two straight strokes

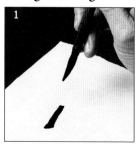

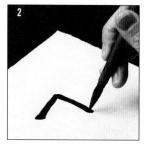

STEP 1
The first stroke is written from left to right.

STEP 2
Add another downward stroke at the end of the first. The corner should form a crisp angle.

Sweeping duck's tail (right)

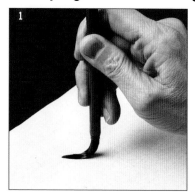

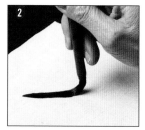

STEP 2
Apply pressure to the bottom of the brush. Pull downward to form a corner.

STEP 3
Continuing your former movement, pull the bristle together to form a point at the end of the stroke.

STEP 1
Tuck in the tip of the brush before starting a thin stroke, carrying it diagonally down and to the right.

Order of strokes

Chinese characters are formed by the combination of various strokes, the number of which can vary greatly. These strokes form components that provide clues to the meaning of the character. However, when attempting to copy a character, it can be difficult to know where to begin the first stroke. Follow the simple guideline "left to right; top to bottom" to help you write any character.

This character is "zhi", which means "to know". There are two components next to one another. Follow the guideline "left to right; top to bottom" and begin at the top left stroke.

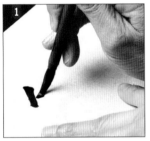

STEP 1
Begin at the top left, with a slanting stroke downwards and to the left; follow this with the first and second horizontal strokes from left to right.

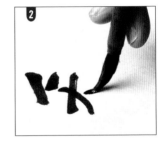

STEP 2
Starting below the top horizontal stroke, add another slanting stroke downwards to its left and a second shorter stroke to its right.

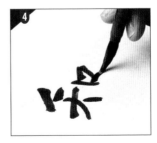

STEP 3
Begin the component on the right "kou" (mouth) by forming a downward vertical stroke; follow this with a horizontal stroke from left to right and continue the horizontal stroke downwards at the corner to form a crisp angle.

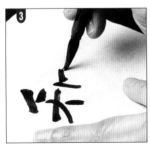

STEP 4
Finish the character by adding a horizontal stroke from left to right to close the box.

How to read a scroll

A scroll is usually a long sheet of calligraphy paper displaying an adage or poem written in calligraphy. There is no punctuation on a scroll. The calligrapher's name can normally be found at the end of the poem, or following a brief description the piece of writing and the date. The calligrapher's "name seal" will appear below his/her name, while other red "leisure seals" frequently adorn the calligraphy. These can be any shape and are usually engraved with words of wisdom. Scrolls are read from top to bottom, right to left (beginning in the top right corner and ending in the bottom left corner).

The two seals here, by the side of the artist's name, are usually engraved with his or her name. Chinese artists usually have two names, or more. One is given by the parents, the other one is used only in the context of calligraphy, painting, or poetry.

Horizontal scroll
This scroll is by Feng Tzu Chan and is a poem written by him in Seal Script. It describes why he is blessed to live in the beautiful city of Vancouver.

The calligrapher signs his or her work, as in this piece by Feng Tzu Chan (Yin Feng Dao Ren at 94 years old).

Start reading here and work downward, reading from right to left.

Finish reading here.

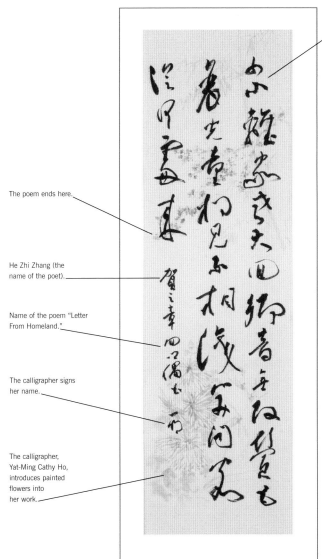

Start reading here and read downward.

The poem ends here.

He Zhi Zhang (the name of the poet).

Name of the poem "Letter From Homeland."

The calligrapher signs her name.

The calligrapher, Yat-Ming Cathy Ho, introduces painted flowers into her work.

Vertical scroll
The calligraphy in this vertical scroll is a poem by He Zhi Zhang. The poem tells of a man who returns to his home town after years away and is greeted by a child who asks where he is from.

筆順指南

Directory of
Chinese Characters

Chapter two

How to use the directory

Have a look at the brush stroke techniques in the previous chapter before starting with the characters in this section. When you are ready to begin, start with the category of numbers first (see page 48), as these are the easiest to master.

Category
This tells you the themed category you are in. There are 15 categories in total.

Directory of Chinese characters (pages 38–231)
There are over 300 characters in the directory.

Step numbers
This tells you which strokes refer to each character.

Transliteration guide
This shows the word written using the Roman alphabet, including stress syllables to help with pronunciation.

Numbered strokes
The order of strokes is clearly illustrated with numbers in each square, giving directions for the formation of each character.

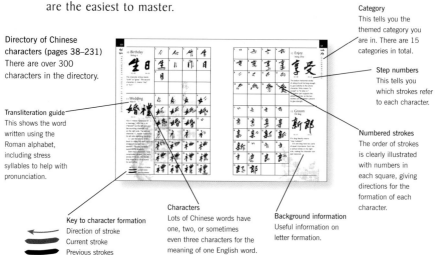

Key to character formation
Direction of stroke
Current stroke
Previous strokes

Characters
Lots of Chinese words have one, two, or sometimes even three characters for the meaning of one English word.

Background information
Useful information on letter formation.

Character selector (pages 42–47)
To help you select the character you want, turn the page to find all the Chinese characters set out in the order they appear. Flip though this part to find an appropriate character to express that special sentiment.

Chinese flower painting (pages 224–231)
To add a modern touch to your calligraphy pieces, you may wish to incorporate some traditional Chinese flowers, painted in a classic Chinese style.

Page numbers
This tells you which page to go to.

Step-by-steps
Sequences show how to create the flower.

Mixing phrases and words

In the directory, there are phrases to denote happiness, thoughtfulness, encouragement, spiritual fulfillment, and congratulatory greetings. You can write them directly on their own, or combine two or three words together to convey an individual and meaningful greeting.

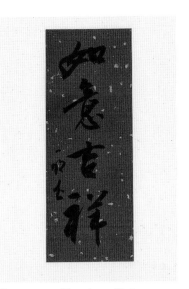

The message on this card says, "Best wishes and best of luck."

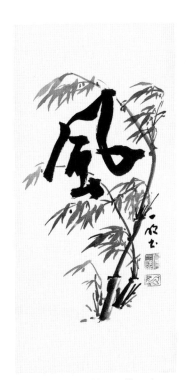

Image and word combine on this card, which says "Wind."

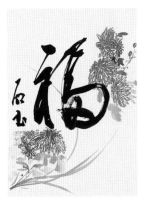

The message here is "Blessing."

48 Numbers	**48** Numbers	**49** Numbers	**49** Numbers	**50** Numbers	**50** Numbers
One Yī 一	Two Èr 二	Three Sān 三	Four Sì 四	Five Wǔ 五	Six Liù 六
51 Numbers	**51** Numbers	**52** Numbers	**52** Numbers	**53** Numbers	**53** Numbers
Seven Qī 七	Eight Bā 八	Nine Jiǔ 九	Ten Shí 十	Eleven Shí yī 十一	Twelve Shí èr 十二
54 Numbers	**54** Numbers	**54** Numbers	**54** Numbers	**54** Numbers	**54** Numbers
Thirteen Shí sān 十三	Fourteen Shí sì 十四	Fifteen Shí wǔ 十五	Sixteen Shí liù 十六	Seventeen Shí qī 十七	Eighteen Shí bā 十八
54 Numbers	**54** Numbers	**55** Numbers	**55** Numbers	**55** Numbers	**55** Numbers
Nineteen Shí jiǔ 十九	Twenty Èr shí 二十	Twenty-one Èr shí yī 二十一	Thirty Sān shí 三十	Forty Sì shí 四十	Fifty Wǔ shí 五十
55 Numbers	**55** Numbers	**55** Numbers	**55** Numbers	**56** Numbers	**56** Numbers
Sixty Liù shí 六十	Seventy Qī shí 七十	Eighty Bā shí 八十	Ninety Jiǔ shí 九十	One hundred Yī bǎi 一百	Thousand Qiān 千
57 Numbers	**57** Numbers	**58** Days	**58** Days	**59** Days	**59** Days
Ten thousand Wàn 萬	Million Yì 億	Today Jīn tiān 今天	Yesterday Zuó tiān 昨天	Monday Xīng qī yī 星期一	Tuesday Xīng qī èr 星期二
60 Days	**60** Days	**61** Days	**61** Days	**62** Days	**62** Days
Wednesday Xīng qī sān 星期三	Thursday Xīng qī shèng 星期四	Friday Xīng qī wǔ 星期五	Saturday Xīng qī liù 星期六	Sunday Xīng qī rì 星期日	Weekend Zhōu mò 週末
63 Days	**63** Days	**64** Days	**64** Days	**65** Days	**65** Days
Tomorrow Míng tiān 明天	Dawn Lí míng 黎明	Morning Zǎo chén 早晨	Midday Zhèng wǔ 正午	Afternoon Xià wǔ 下午	Evening Huáng hūn 黃昏
66 Days	**66** Days	**67** Days	**67** Days	**68** Months	**68** Months
Night Wǎn shàng 晚上	Midnight Wǔ yè 午夜	Time Shí jiān 時間	Moment Shí kè 時刻	January Yī yuè 一月	February Èr yuè 二月
69 Months	**69** Months	**70** Months	**70** Months	**71** Months	**71** Months
March Sān yuè 三月	April Sì yuè 四月	May Wǔ yuè 五月	June Liù yuè 六月	July Qī yuè 七月	August Bā yuè 八月

72 Months	72 Months	73 Months	73 Months	74 Seasons	74 Seasons
September Jiǔ yuè	October Shí yuè	November Shí yī yuè	December Shí èr yuè	Four seasons Sì jì	Spring Chūn
九月	十月	十一月	十二月	四季	春
75 Seasons	**75** Seasons	**76** Seasons	**76** Seasons	**77** Seasons	**77** Seasons
Summer Xià	Fall Qiū	Winter Dōng	Sun Rì	Moon Yuè	Star Xīng rì
夏	秋	冬	日	月	星
78 Pronouns	**78** Pronouns	**79** Pronouns	**79** Pronouns	**80** Pronouns	**80** Pronouns
I Wǒ	You Nǐ	He Tā rén	She Tā nǚ	We Wǒ men	You (plural) Nǐ men
我	你	他	她	我們	你們
81 Pronouns	**81** Pronouns	**82** People	**82** People	**83** People	**83** People
They Tā men	They (female) Tā men	Grandfather Zǔ fù	Grandmother Zǔ mǔ	Father Fù qīn	Mother Mǔ qīn
他們	她們	祖父	祖母	父親	母親
84 People	**84** People	**85** People	**85** People	**86** People	**86** People
Brother Xiōng dì	Sister Zǐ mèi	Maternal grandfather Wài zǔ fù	Maternal grandmother Wài zǔ mǔ	Married couple Fū fù	Husband Zhàng fū
兄弟	姊妹	外祖父	外祖母	夫婦	丈夫
87 People	**87** People	**88** People	**88** People	**89** People	**89** People
Wife Qī zǐ	Baby Yīng ér	Daughter Nǚ ér	Son Ér zǐ	Child Hái zǐ	Grandchild Sūn
妻子	嬰兒	女兒	兒子	孩子	孫
90 People	**90** People	**91** People	**91** People	**92** People	**92** People
Fraternal Niece Zhí nǚ	Nephew Zhí zǐ	Paternal Aunt Gū	Maternal Aunt Yí	Uncle (father's brother) Shū bó	Uncle (mother's brother) Jiù
姪女	姪子	姑	姨	叔伯	舅
93 People	**93** People	**94** People	**94** People	**95** People	**95** People
Maternal nephew Wài shēng	Maternal niece Wài shēng nǚ	Cousin Biǎo gē	Godparents Jiào fù mǔ	Teacher Lǎo shī	Student Xué shēng
外甥	外甥女	表	教父母	老師	學生
96 People	**96** People	**97** People	**97** People	**98** Chinese zodiac	**98** Chinese zodiac
Neighbor Lín jū	Best friend Zhī jǐ	Lover Qíng rén	Friend Péng yǒu	Rat Shǔ	Ox Niú
鄰居	知己	情人	朋友	鼠	牛
99 Chinese zodiac	**99** Chinese zodiac	**100** Chinese zodiac	**100** Chinese zodiac	**101** Chinese zodiac	**101** Chinese zodiac
Tiger Hǔ	Rabbit Tù	Dragon Lóng	Snake Shé	Horse Mǎ	Ram Yáng
虎	兔	龍	蛇	馬	羊

102 Chinese zodiac	102 Chinese zodiac	103 Chinese zodiac	103 Chinese zodiac	104 Greetings	104 Greetings
Monkey Hóu	Rooster Jī	Dog Gǒu	Pig Zhū	Good morning Zǎo ān	Good day Jīn tiān hǎo
猴	雞	狗	豬	早安	今天好

105 Greetings	105 Greetings	106 Greetings	106 Greetings	107 Greetings	108 Greetings
Hello Nǐ hǎo	How are you? Nǐ hǎo má	Good afternoon Wǔ ān	Good night Wǎn ān	Dear Qīng ài de	Please Qǐng
你好	你好嗎?	午安	晚安	親愛的	請

108 Greetings	109 Greetings	109 Greetings	110 Greetings	110 Greetings	111 Greetings
Best wishes Zhù fú	It's great! Liǎo bù qi	Take care Bǎo zhòng	Cheers! Zhù hǎo	Cheers! Gān bēi	Goodbye Zài jiàn
祝福	了不起	保重	祝好	乾杯	再見

111 Greetings	112 Greetings	113 Greetings	113 Greetings	114 Celebrations	115 Celebrations
Good Hěn hǎo	Thank You Xiè xiè nǐ	Visit Tàn wàng	Haven't seen you for a long time Hǎo jiǔ bù jiàn	Happy birthday Kuài lè shēng rì	Celebrate Qìng zhù
很好	謝謝你	探望	好久不見	生日快樂	慶祝

115 Celebrations	116 Celebrations	117 Celebrations	117 Celebrations	118 Celebrations	118 Celebrations
Birth Dàn shēng	Anniversary Zhōu nián jì niàn	Marriage Jié hūn	Engagement Dìng hūn	Fun Qù zǒu	Bride Xīn niáng
誕生	週年紀念	結婚	訂婚	趣	新娘

119 Celebrations	120 Celebrations	120 Celebrations	121 Celebrations	121 Celebrations	122 Celebrations
Marriage made in heaven Jiā ǒu tiān chéng	Birthday Shēng rì	Wedding Hūn lǐ	Enjoy Xiǎng shòu	Groom Xīn láng	Congratulations Zhù hè
佳偶天成	生日	婚禮	享受	新郎	祝賀

122 Celebrations	123 Celebrations	124 Celebrations	125 Celebrations	126 Celebrations	126 Celebrations
Graduation Bì yè	Good business Shēng yì xīng lóng	Happy New Year Xīn nián kuài lè	Best wishes for prosperity Gōng xǐ fā cái	Surprise Jīng qí	Retirement Tuì xiū
畢業	生意興隆	新年快樂	恭喜發財	驚奇	退休

127 Celebrations	128 Celebrations	129 Celebrations	129 Celebrations	130 Celebrations	130 Celebrations
Best wishes and best of luck Rú yì jí xiáng	Welcome Huān yíng	Gift Lǐ wù	Baptism Jìn lǐ	Rejoice Xǐ lè	Christening Xǐ lǐ
如意吉祥	歡迎	禮物	浸礼	喜樂	洗礼

131 Celebrations	132 Festivals	133 Festivals	133 Festivals	134 Festivals	135 Festivals
Hallelujah Zàn měi zhǔ	Dragon Boat Festival Duān wǔ jié	New Year Xīn nián	Chinese New Year Chūn jié	Valentines Day Qíng rén jié	Grave-tending Day Qīng míng jié
讚美主	端午節	新年	春節	情人節	清明節

136 Festivals	137 Festivals	138 Festivals	139 Festivals	140 Festivals	141 Festivals
Good Friday Shòu lán jié	Easter Day Fù huó jié	Mother's Day Mǔ qīn jié	Father's Day Fù qīn jié	Moon festival Zhōng qiū jié	Thanksgiving Day Gǎn ēn jié
受難節	復活節	母親節	父親節	中秋節	感恩節

142 Festivals	**143** Festivals	**144** Affirmations	**144** Affirmations	**145** Affirmations	**145** Affirmations
Hanukkah Yóu tài shèng jiē	Christmas Day Shèng dàn jiē	Freedom Zì yóu	Growth Shēng zhǎng	Smile Wēi xiào	Laugh Xiào
猶太聖節	聖誕節	自由	生長	微笑	笑

146 Affirmations	**146** Affirmations	**147** Affirmations	**147** Affirmations	**148** Affirmations	**148** Affirmations
Health Jiàn kāng	Breathe Hū xī	Courage Yǒng qì	Love Ài	Understanding Míng bái	Admiration Yǎng mù
健康	呼吸	勇氣	愛	明白	仰慕

149 Affirmations	**149** Affirmations	**150** Affirmations	**150** Affirmations	**151** Affirmations	**151** Affirmations
Overcome Kè fú	Fortune Yùn qì	Piety Xiào	Play Wán	Kindness Rén cí	Harmony Hé xié
克服	運氣	孝	玩	仁慈	和諧

152 Affirmations	**152** Affirmations	**153** Affirmations	**153** Affirmations	**154** Affirmations	**154** Affirmations
Sincere Zhēn chéng	Righteous Zhèng yì	Live Shēng huó	Achievement Chéng jiù	Selfless Wú wǒ	Pride Zì zūn
真誠	正義	生活	成就	無我	自尊

155 Affirmations	**155** Affirmations	**156** Affirmations	**156** Affirmations	**157** Affirmations	**157** Affirmations
Loyalty Zhōng	Escape Táo bì	Forgive Shù xīn	Morality Dào dé	Dedication Zhì lì	Explore Tàn cè
忠	逃避	恕	道德	致力	探測

158 Affirmations	**158** Affirmations	**159** Affirmations	**159** Affirmations	**160** Affirmations	**161** Affirmations
Diligent Kè kǔ	Decision Jué dìng	Brave Yǒng gǎn	Work Gōng zuò	Encouragement Gǔ lì	Power Quán
刻苦	決定	勇敢	工作	鼓勵	權

161 Affirmations	**162** Affirmations	**162** Affirmations	**163** Affirmations	**163** Affirmations	**164** Affirmations
Strength Lì liàng	Endurance Rěn	Respect Zūn jìng	Wisdom Zhì	Discover Fā xiàn	Empower Cù shǐ
力量	忍	尊敬	智	發現	促使

164 Affirmations	**165** Affirmations	**165** Affirmations	**166** Affirmations	**166** Affirmations	**167** Affirmations
Create Chuāng zuò	Positive Kěn dìng de	Strive forward Zhēng qǔ	Aim Zōng zhí	Intelligent Cái zhì	Cooperation Hé zuò
創作	肯定的	爭取	宗旨	才智	合作

167 Affirmations	**168** Affirmations	**168** Affirmations	**169** Affirmations	**169** Affirmations	**170** Affirmations
Excellent Yōu xiù	Prosper Shùn lì	Prosper (colloquial) Fā	Happiness Kuài lè	Win Yíng	Assertivness Jiān chí
優秀	順利	發	快樂	贏	堅持

170 Affirmations	**171** Affirmations	**171** Affirmations	**172** Affirmations	**172** Affirmations	**173** Affirmations
Determination Jué xīn	Goal Mù biāo	Reach Dào dá	Trustworthy Kě kào	Hero Yīng xióng	Recognize Rèn kě
決心	目標	到達	可靠	英雄	認可

173 Affirmations	**174** Affirmations	**174** Affirmations	**175** Affirmatives	**176** Love	**176** Love
Recommend Tuī jiàn	Great men Wěi rén	Greatness Wěi dài	Kindness, righteousness, loyalty, and trust Rén, yì, zhōng, xīn	Companion Tóng bàn	Desire Yāo qiú
推荐	伟人	伟大	仁义忠信	同伴	要求

177 Love	**177** Love	**178** Love	**178** Love	**179** Love	**179** Love
Delight Yú kuài	Precious Zhen gui	Beauty Měi	Passion Rè qíng	Heart Xīn	Companion Tǐ xù
愉快	珍贵	美	热情	心	體恤

180 Love	**180** Love	**181** Love	**181** Love	**182** Love	**182** Love
Gentle Wēn yǎ	Bliss Zhì lè	Trust Xìn rèn	Warmth Qīn qiē	Gratitude Xie yi	Caring Xì xīn
文雅	至樂	信任	親切	謝意	細心

183 Love	**184** Love	**184** Love	**185** Love	**185** Love	**186** Love
Embrace Yǒng bào	Together Yī qǐ	Cherish Zhēn xī	Ecstasy Rù mí	Tender Wēn róu	Radiant Míng yàn
擁抱	一起	珍惜	入迷	温柔	明豔

187 Love	**187** Love	**188** Love	**188** Love	**189** Love	**190** Meditations
Sympathy Tóng qíng	Friendship Yǒu yì	Pretty Piào liang	Union Jié hé	Grace Yōu yǎ	Yin Yīn
同情	友誼	漂亮	結合	優雅	陰

190 Meditations	**191** Meditations	**192** Meditations	**192** Meditations	**193** Meditations	**193** Meditations
Yang Yáng	Soul Líng hún	Thought Sī OR Xīn	Meditation Míng xiǎng	T'ai chi Tài jí	Taoism Dào
陽	靈魂	思	冥想	太極	道

194 Meditations	**194** Meditations	**195** Meditations	**195** Meditations	**196** Meditations	**196** Meditations
No Limit Wú jí	Nothingness Kōng	Realization Wù	Harmony Hé xié	Carefree Zì zài	Spirit Jīng shén
無極	空	悟	和諧	自在	精神

197 Meditations	**197** Meditations	**198** Meditations	**198** Meditations	**199** Meditations	**199** Meditations
Fulfillment Wán chéng	Journey Lǚ chéng	Acceptance Jiē shòu	Belief Xìn niàn	Mystery Xuán miào	Miracle Qí jí
完成	旅程	接受	信念	玄妙	奇跡

200 Meditations	**200** Meditations	**201** Meditations	**202** Meditations	**202** Meditations	**203** Meditations
Imagine Xiǎng xiàng	Insight Wù lì	Inspiration Líng gǎng	Calm Píng jìng	Awakening Qǐ shì	Angel Tiān shǐ
想像	悟力	靈感	平靜	啟示	天使

203 Meditations	**204** Meditations	**204** Meditations	**205** Meditations	**205** Meditations	**206** Meditations
Divine Shén shèng	Faith Xīn yǎng	Destiny Mìng yùn	Relax Fàng kūan	Vision Huàn xiàng	Truth Zhēn xiàng
神聖	信仰	命運	放寬	幻像	真相

206 Meditations	**207** Meditations	**207** Meditations	**208** Meditations	**208** Meditations	**209** Meditations
Dream Mèng	Sorrow Xīn chóu	Memories Huí yì	Eternity Yǒng héng	Balance Píng héng	Patience Nài xīn
夢	愁	回憶	永恆	平衡	耐心
209 Meditations	**210** Meditations	**210** Meditations	**211** Meditations	**211** Meditations	**212** Meditations
Surrender Shě qì	Wish Dàn yuàn	Tranquility Jìng	Metal Jīn	Wood Mù	Water Shuǐ
捨棄	但願	靜	金	木	水
212 Meditations	**213** Meditations	**213** Meditations	**214** Prayers	**214** Prayers	**215** Prayers
Fire Huǒ	Earth Tǔ	Five elements Wǔ xíng	Buddha Fó	Zen Chán	Serenity Níng
火	土	五行	佛	禪	寧
215 Prayers	**216** Prayers	**216** Prayers	**217** Prayers	**217** Prayers	**218** Blessings
Bless Zhù fú	God Shén	Pray Qí dǎo	Heaven Tiān táng	Wish Xī wàng	Blessings Fú
祝福	神	祈禱	天堂	希望	福
218 Blessings	**219** Blessings	**219** Blessings	**220** Blessings	**220** Blessings	**221** Blessings
Stability Wěn	Joy Xǐ yuè	Peace Hé píng	Prosperity Shùn lì	Wealth Cái fù	Expansion Kuò dà
穩	喜悅	和平	順利	財富	擴大
221 Blessings	**222** Blessings	**222** Blessings	**223** Blessings	**223** Blessings	
Forever Yǒng	Success Chéng gōng	Luck Jí xiáng	Safe Píng ān	Longevity Cháng shòu	
永	成功	吉祥	平安	長壽	

Numbers

Chinese numbers are a great place to start practicing calligraphy. They have few strokes and are easy to master. The characters after number ten build on the numbers previously learned.

	1			
One Yī				
Yī is a single stroke written from left to right. The stroke must be bold and deliberate.				

	1	2		
2 **Two** Èr				
Èr contains two strokes written from left to right. Note that the upper stroke is shorter than the one below.				

direction of stroke
current stroke
previous strokes

1	2	3	

3 Three
Sān

Ensure that the middle stroke is the shortest, leaving space for the other two.

1	2	3	4
5			

4 Four
Sì

Make sure to complete the lower horizontal stroke last, to close the box.



5 Five
Wǔ

The vertical strokes of wǔ sit comfortably on the long bottom stroke.

1	2	3	4
5			

6 Six
Liù

The "dot" or "short stroke" of this number is written in three stages: press the tip of the brush down, pull, and then tuck in the tip to form a triangle. Remember to keep the brush constantly moving, or the ink will spread.

1	2	3	4

direction of stroke
current stroke
previous strokes

1	2		

7 Seven
Qī

When writing the second stroke of this character, make sure you lift the tip of the brush for the bend before pulling to the right.

1	2		

8 Eight
Bā

Both two strokes are written downward to form a stable stand.

9 Nine
Jiǔ

1	2	3	4

Jiǔ has a long stroke bending to the right. Remember to lift the tip of the brush when writing a curved line. Add the flick only after you have completed the previous stroke.

10 Ten
Shí

1	2	

Shí is like a "plus" sign; place the horizontal stroke before the vertical line.

direction of stroke
current stroke
previous strokes

1	2	3	
➘	十	➘	

11 Eleven
Shí yī

01–02　　　　03

Eleven means ten and one, so in Chinese, it is simply shí yī. Write shí first, then yī to complete the number.

1	2	3	4
➘	十	➘	➘

12 Twelve
Shí èr

01–02　　　　03–04

Writing numbers is a good way to practice stroke techniques, and the characters learned so far in this chapter are all used time and time again when composing all numbers, as well as months, years, days, and much more.

Master numbers 1–12 on the previous pages, and you can write any number you like. For example, for 13, the digit representing 10 is written first followed by the number 3.

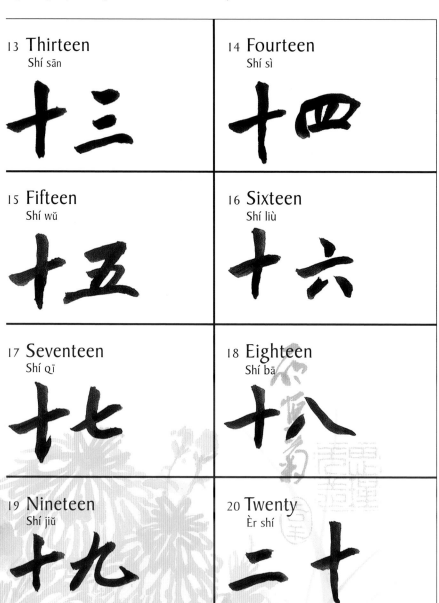

13 **Thirteen**
Shí sān

14 **Fourteen**
Shí sì

15 **Fifteen**
Shí wǔ

16 **Sixteen**
Shí liù

17 **Seventeen**
Shí qī

18 **Eighteen**
Shí bā

19 **Nineteen**
Shí jiǔ

20 **Twenty**
Èr shí

21 Twenty-one
Ér shí yī

二十一

22 Thirty
Sān shí

三十

23 Forty
Sì shí

四十

24 Fifty
Wǔ shí

五十

25 Sixty
Liù shí

六十

26 Seventy
Qī shí

七十

27 Eighty
Bā shí

八十

28 Ninety
Jiǔ shí

九十

29 One hundred
Yī bǎi

01–02 03–07

Bǎi means hundred. One hundred is yī bǎi, two hundred is èr bǎi, three hundred is sān bǎi, and so on.

1	2	3	4
5	**6**	**7**	

30 Thousand
Qiān

1	2	3	

Qiān contains only three strokes. Write in the right order and with the right posture. Five thousand is written as wǔ qiān.

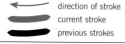
direction of stroke
current stroke
previous strokes

1	2	3	4
5	6	7	8
9	10	11	12
13			

31 Ten thousand
Wàn

萬

Wàn has more strokes than any of the previous numbers. The strokes have to be smaller to accommodate the whole character.

1	2	3	4
5	6	7	8
9	10	11	12
13	14	15	

32 Million
Yì

億

Yì has two parts, and should be written from left to right. The left side means people, and the right side gives the sound yì.

Days and time of day

Sequential numbers are often used in the compilation of Chinese characters. Each day of the week is assigned a number: Monday is weekday one and so on up to Saturday, which is weekday six. Sunday is not regarded as the seventh day but as a special day, so rì is used to describe it.

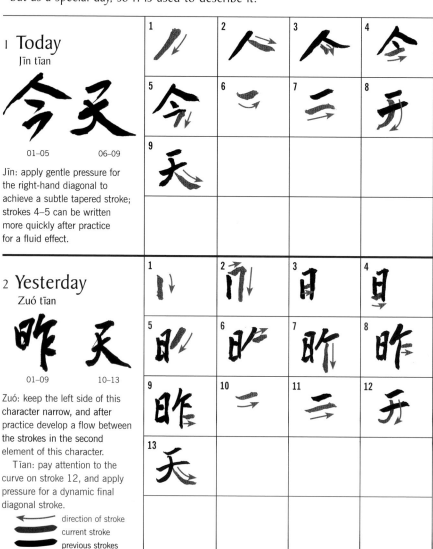

1 Today
Jīn tiān

今天

01–05 06–09

Jīn: apply gentle pressure for the right-hand diagonal to achieve a subtle tapered stroke; strokes 4–5 can be written more quickly after practice for a fluid effect.

2 Yesterday
Zuó tiān

昨天

01–09 10–13

Zuó: keep the left side of this character narrow, and after practice develop a flow between the strokes in the second element of this character.

Tiān: pay attention to the curve on stroke 12, and apply pressure for a dynamic final diagonal stroke.

direction of stroke
current stroke
previous strokes

1	2	3	4
5	6	7	8
9	10	11	12
13	14	15	16
17	18	19	20
21	22		

3 Monday
Xīng qī yī

星期一

01–09 10–21 22

Add the number 1, "yī," to the first day of the week, as a long horizontal stroke.

1	2	3	4
5	6	7	8
9	10	11	12
13	14	15	16
17	18	19	

4 Tuesday
Xīng qī èr

星期二

01–07 08–17 18–19

Èr: note the different widths of these two strokes, which make the numeral 2.

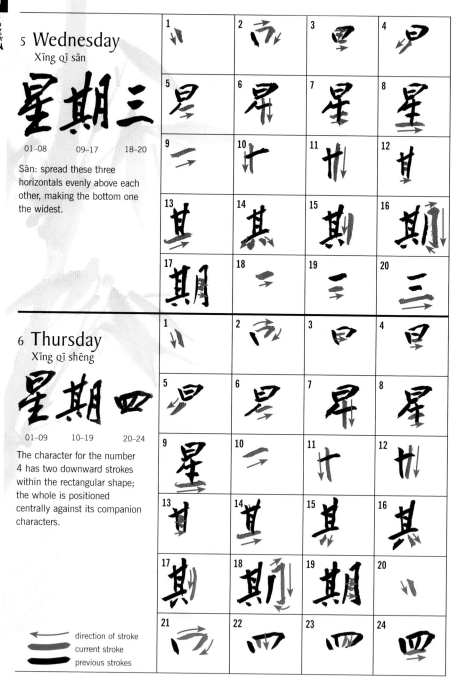

5 Wednesday
Xīng qī sān

01–08 09–17 18–20

Sān: spread these three horizontals evenly above each other, making the bottom one the widest.

6 Thursday
Xīng qī shēng

01–09 10–19 20–24

The character for the number 4 has two downward strokes within the rectangular shape; the whole is positioned centrally against its companion characters.

direction of stroke
current stroke
previous strokes

1	2	3	4
5	6	7	8
9	10	11	12
13	14	15	16
17	18	19	20
21	22	23	24

7 Friday
Xīng qī wǔ

星 期 五

01–09　　10–20　　21–24

Wǔ: the zigzag rhythm of this numeral 5 is completed with a wide, balancing baseline.

1	2	3	4
5	6	7	8
9	10	11	12
13	14	15	16
17	18	19	

8 Saturday
Xīng qī liù

星 期 六

01–07　　08–16　　17–20

Liù: for the numeral six, spread the last two strokes out to balance the strokes above, in triangular formation.

9 Sunday
Xīng qī rì

01–09 10–20 21–24

The Chinese character for the seventh day is not seven, but rì ("sun"). Rì is a rectangular shape, with a dot (short stroke) in the middle. If rì is written wider than this, it has another meaning.

10 Weekend
Zhōu mò

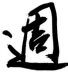

01–12 13–17

Note that the second horizontal stroke in the character mò is shorter than the one above it. Take care when writing this, as it will become another character if the bottom stroke is any longer.

direction of stroke
current stroke
previous strokes

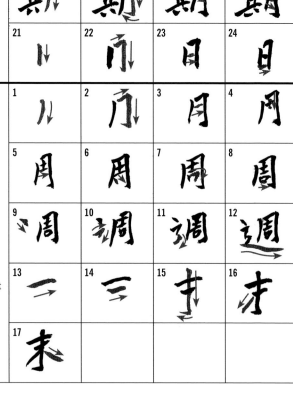

1	**2**	**3**	**4**
5	**6**	**7**	**8**
9	**10**	**11**	**12**

11 Tomorrow
Míng tīan

01–08　　　　09–12

Míng: keep the "moon" and "sun" rectangular elements narrow and centralized to each other.
　Tīan: As in "yesterday" and "today," apply pressure for that dynamic final diagonal stroke.

1	**2**	**3**	**4**
5	**6**	**7**	**8**
9	**10**	**11**	**12**
13	**14**	**15**	**16**
17	**18**	**19**	**20**
21	**22**	**23**	

12 Dawn
Lí míng

01–15　　　　16–23

Here, míng is used to indicate that the light has arrived.
　Lí has two parts, which have 15 strokes. When writing these characters, allow sufficient space for both parts to sit comfortably side by side.

13 Morning
Zǎo chén

01–06 07–17

Zǎo: keep the cross of sufficient depth to match with chén.

Chén: try not to lose track of how many strokes are in this character; balance the last diagonal against the earlier one.

1	2	3	4
5	6	7	8
9	10	11	12
13	14	15	16
17			

14 Midday
Zhèng wǔ

01–05 06–09

Zhèng: keep the final stroke along the bottom the widest.

Wǔ: make the final upright stroke support the structure firmly.

1	2	3	4
5	6	7	8
9			

direction of stroke
current stroke
previous strokes

15 Afternoon
Xià wŭ

01–03 04–07

These characters are of few strokes so pay attention to their relative proportions and balance the two against each other.

16 Evening
Huáng hūn

01–11 12–20

Huáng: keep the second horizontal the widest stroke and spread the final dots like feet to balance the form.

Hūn: Keep the diagonal in step 16 wide enough to cover the "sun" underneath.

17 Night
Wǎn shàng

晚 上

01–12 13–15

Wǎn: the two elements are written close together; the final open stroke in step 12 contrasts with the tight complexity above.

Shàng: make the horizontal line a sturdy base.

1	2	3	4
5	6	7	8
9	10	11	12
13	14	15	

18 Midnight
Wǔ yè

午 夜

01–04 05–12

Wǔ (as seen in "afternoon"): keep the vertical stroke the longest.

Yè: position the left and right elements beneath the horizontal above until the final dynamic diagonal, which escapes to the right.

1	2	3	4
5	6	7	8
9	10	11	12

direction of stroke
current stroke
previous strokes

1	2	3	4
5	6	7	8
9	10	11	12
13	14	15	16
17	18	19	20
21	22		

19 Time
Shì jián

01–10 11–22

When we speak of time we say "shì jián." Both characters have a rì (sun) in them. The rì resides at the left side of shì (hour or time) and it is always better to place it at the upper half for the character to balance well. Jián means "between" with the rì at the middle of a "door." When writing this "door" you should have the left side shorter than the right, to balance the character.

1	2	3	4
5	6	7	8
9	10	11	12
13	14	15	16
17	18		

20 Moment
Shì kè

01–10 11–18

Shì is "time" and kè means "short." The character ke also means "engrave" so there is a form of knife at its right, which has the same importance as its left. Strike it down to the bottom with deliberation.

Months

Numbers 1 through 12 are used to describe the order of months, making January month 1, February month 2, March month 3, and so on until month 12 (December). The Chinese calendar is based on the phases of the moon; the character for month is yuè, which means "moon."

1 January
Yī yuè

01–02 03–05

In China, months are referred to by number. January is the first month of the year, so it is yī yuè.

1	2	3	4
5			

2 February
Èr yuè

01–02 03–06

February is the second month. Yuè means moon; the shape of the character looks like the new moon.

1	2	3	4
5	6		

direction of stroke
current stroke
previous strokes

1	2	3	4
5	6	7	8

3 March
Sān yuè

01–03 04–08

March is the third month of the year, so "sān" is used to describe it.

1	2	3	4
5	6	7	8
9	10		

4 April
Sì yuè

01–05 06–10

The fourth month, sì yuè, is April.

5 May
Wǔ yuè

五 月

01–04 05–09

Wǔ yuè is May, the fifth month. Numbers are the first things you should learn in Chinese, as they are used quite often in phrases and idioms.

1	2	3	4
5	6	7	8
9			

6 June
Liù yuè

六 月

01–04 05–09

Liù yuè is June, the sixth month of the year. Yuè is long and elegant.

1	2	3	4
5	6	7	8
9			

direction of stroke
current stroke
previous strokes

1	2	3	4
一	七		
5	6	7	
	月	月	

7 July
Qì yuè

01–02 03–07

When you write yuè, be sure to have two downward strokes, one to the left can end in a point and another with a flick at the end.

1	2	3	4
	八		
5	6	7	
	月	月	

8 August
Bā yuè

01–02 03–07

These two characters complement each other, with bā being wide open and yuè forming a long willowy style.

9 September
Jiǎ yuè

九 月

01–02 04–08

The ninth month, Jiǎ yuè, is aesthetically pleasing, and very simple to construct.

1	2	3	4
丿	九	九	儿
5	**6**	**7**	**8**
厂	几	月	月

10 October
Shí yuè

十 月

01–02 03–07

Shí yuè is the tenth month. Remember to turn the brush every now and then to adjust the point so the strokes will turn out rounded, not flat.

1	2	3	4
一	十	丿	厂
5	**6**	**7**	
几	月	月	

direction of stroke
current stroke
previous strokes

1	2	3	4
5	6	7	8

11 November
Shí yī yuè

十一月

01–02 03 04–08

The eleventh month has three characters to describe it. Hold the brush as if it is the extension of your hand—every stroke is in your control.

1	2	3	4
5	6	7	8
9			

12 December
Shí èr yuè

十二月

01–02 03–04 05–09

The second character èr can be written slightly smaller to allow the three characters to fit together comfortably.

Seasons

Chūn, xià, qiū, and dōng are the four seasons (sì jì), and each has sweeping strokes extending from both sides of the characters. Balance is an important consideration: only one sweeping stroke can be expressed outwardly, so if there are two within one character, one of them will have to be written differently.

1 Four seasons
Sì jì

01–05 06–14

Jì means "season." It has two strokes in its upper part that extend outward, creating a sense of balance, with a lower horizontal stroke that supports the weight on its shoulders.

1	2	3	4
5	6	7	8
9	10	11	12
13	14		

2 Spring
Chūn

Chūn is the first season in the year. You can see rì ("sun") shining from below, with vegetation and plants on top beginning to shoot out.

1	2	3	4
5	6	7	8
9			

direction of stroke
current stroke
previous strokes

1	2	3	4
5	6	7	8
9	10		

3 Summer
Xià

The long top line is counterbalanced by the lower diagonals, especially the dynamic final stroke.

1	2	3	4
5	6	7	8
9			

4 Fall
Qiū

In the character qiū, "crops" (hé) appears on the left and "fire" (huǒ) is expressed on the right. Extend the last sweeping stroke to the right to form an elegant character.

5 Winter
Dōng

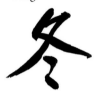

1	2	3	4
5	6		

Dōng ("winter") means "end," and the dots below denote "the cold solid state of water" (ice). Allow the dots to point in slightly different directions, without spoiling the natural flow. Follow the direction of the brush.

6 Sun
Rì

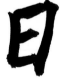

1	2	3	4
5			

Chinese characters are derived from pictograms—rì originated as a picture of the sun. The stroke in step 3 should be slightly longer than the stroke on the left of the character.

direction of stroke
current stroke
previous strokes

1	2	3	4
5			

7 Moon
Yuè

Yuè originated from a pictogram, which implies a new moon with the two short strokes inside as shadows. Sweep the first stroke downward and toward the left, and then balance it with the downward stroke on the right, ending in a flick.

1	2	3	4
5	6	7	8
9	10		

8 Star
Xīng rì

The steps show Kai Shu (Regular Style), but for Running Script (Xin Shu) you can write the two horizontal strokes one after the other (steps 9 and 10), including a light linking stroke, in between.

Pronouns

The pronouns given here are for the first, second, and third person, both singular and plural. Gender is indicated with the use of nǚ (female) at the left side of the characters, though the pronunciation remains the same. An extra character men is added when more than one person is expressed.

1 I
Wǒ

1	2	3	4
5	6	7	

Wǒ means "I" or "me." The right side is ge (a sword); the left side is linked to the right side with the top horizontal stroke. The two sides slope inward before extending outward but take care not to extend them too far.

2 You
Nǐ

1	2	3	4
5	6	7	

Nǐ means "you," the person opposite you, and is only used when talking to one person. When you are talking to more than one person, you need to add men to nǐ to address them (see page 80).

direction of stroke
current stroke
previous strokes

1	2	3	4
5			

3 He
Tā rén

There are different ways of writing the third-person pronoun, depending on the gender of the person being referred to, although the pronunciation is the same. Here, the left side of tā includes the character rén ("person"). In order to distinguish the gender of the person, rén here is used as the male gender. Note the long stroke in step 5, where you need to lift the brush slightly to curve it toward the right. Practice this stroke until it becomes easy.

1	2	3	4
5	6		

4 She
Tā nǚ

When used to mean "she," the left side of tā incorporates the character nǚ ("female")—so we know that the person being referred to is female.

The final "flick" in this character (step 6) is important to make the character look right. Adjust it according to the other parts of the character, either making it stand upright or saluting the left part.

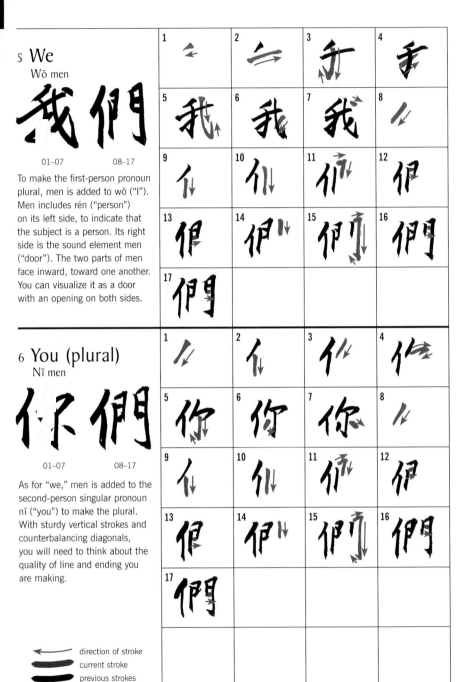

5 We
Wǒ men

01–07 08–17

To make the first-person pronoun plural, men is added to wǒ ("I"). Men includes rén ("person") on its left side, to indicate that the subject is a person. Its right side is the sound element men ("door"). The two parts of men face inward, toward one another. You can visualize it as a door with an opening on both sides.

6 You (plural)
Nǐ men

01–07 08–17

As for "we," men is added to the second-person singular pronoun nǐ ("you") to make the plural. With sturdy vertical strokes and counterbalancing diagonals, you will need to think about the quality of line and ending you are making.

direction of stroke
current stroke
previous strokes

1	2	3	4
5	6	7	8
9	10	11	12
13	14	15	

7 They
Tā men

他們

01–05 06–15

When Chinese people refer to a group of people, they use the pronoun tā men. If the group is all male, or made up of both men and women, the character tā should have a rén on its side—just as it does in the masculine third-person singular pronoun, "he." This does not affect the pronunciation.

1	2	3	4
5	6	7	8
9	10	11	12
13	14	15	16

8 They (female)
Tā men

她們

01–06 07–16

When tā men is used to refer to an all-female group, tā has a nǔ ("female") on its left side—just as it does in the feminine third-person singular pronoun, "she."

In the second character, men, the three downward strokes are straight and upright. To balance and give some liveliness to the character, the middle downward stroke can be slightly shorter than the other two.

People

There are different ways to address relatives on the maternal and paternal sides of a family. Relations on the sister's, daughter's, or mother's side contain the character "wài" ("outside") to indicate that they don't share the ancestral surname.

1 Grandfather
Zǔ fù

01–09 10–13

Zǔ: the left-hand character is finely balanced; notice the placing of vertical stroke 3, forming a fulcrum.

2 Grandmother
Zǔ mǔ

01–09 10–14

The left side of "zǔ" indicates the meaning "ceremonial and seniority." Hence, zǔ is used for words in the context of ancestors.

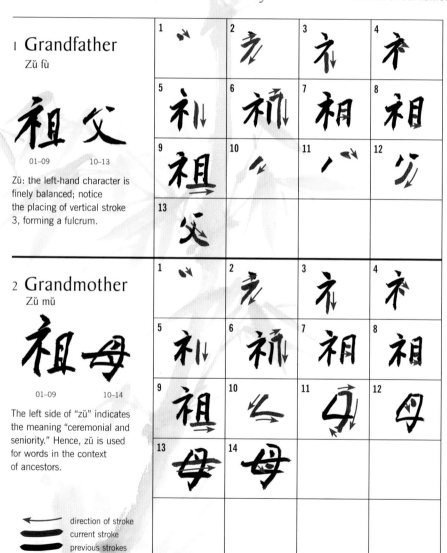

direction of stroke
current stroke
previous strokes

1	2	3	4
5	6	7	8
9	10	11	12
13	14	15	16
17	18	19	

3 Father
Fù qīn

01–04 05–19

"Bà ba" is often used casually at home when speaking to one's father, but the example here, "fù qīn," is the more formal expression.

"Qīn" means "affectionate" and is also used in the context of "mother" as well as the parents of the in-laws.

1	2	3	4
5	6	7	8
9	10	11	12
13	14	15	16
17	18	19	

4 Mother
Mǔ qīn

01–05 06–19

"Mā mā" is the informal way of addressing one's "Mom," whereas "mǔ qīn" is the more formal expression.

These two characters have very different forms, with one having far fewer strokes than the other. Treat them in the same way so that they completely fill the space in the block with the strokes available. Make sure that the characters look well balanced.

5 Brother
Xiōng dì

01–05 06–13

The example shown here is for "older and younger brothers." The first character, xiōng, means "older brother," and dì means "younger brother." Xiōng dì are often used together to describe one's siblings.

An older brother is also addressed as "gē gē" and a younger brother as "dì dì."

1	2	3	4
5	6	7	8
9	10	11	12
13			

6 Sister
Zǐ mèi

01–08 09–13

Both characters have "female" on their left, but can be written with variation in the brush treatment to add visual interest. The right-hand elements in both cases have vertical structures, but the base "flick" is optional.

1	2	3	4
5	6	7	8
9	10	11	12
13	14	15	16

direction of stroke
current stroke
previous strokes

PEOPLE

7 Maternal grandfather

Wài zǔ fù

外祖父

01–05　　06–14　　15–18

Wài: the first 3 strokes are supported by the upright, and balanced by the final outward stroke.

8 Maternal grandmother

Wài zǔ mǔ

外祖母

01–05　　06–14　　15–19

A maternal grandmother is addressed as "wài zǔ mǔ." The character "wài," meaning outside, is added whenever the relatives of a mother, daughter, or sister are addressed.

DIRECTORY OF CHINESE CHARACTERS

9 Married couple
Fū fù

01–08 09–15

Fū (husband): balance the curved diagonal strokes and apply pressure then release for a pointed end.

Fù (woman): keep the "female" character of two interlocked V shapes smaller than the right-hand "brush." Position the upright stroke to support the other elements and tie them together.

1	2	3	4
5	6	7	8
9	10	11	12
13	14	15	

10 Husband
Zhàng fū

01–03 04–07

The characters "zhàng fū" have only a few strokes. However, each character has two sweeping strokes that should be extended so they appear elegant and lively.

1	2	3	4
5	6	7	

direction of stroke
current stroke
previous strokes

1	2	3	4
5	**6**	**7**	**8**
9	**10**	**11**	

11 Wife
Qī zǐ

01–08 09–11

Qī: ensure that the lower horizontal (step 8) is widest, part of the "female" symbol, supporting the upper structure and balanced by the diagonals below.

Zǐ: enjoy the kick on step 10, which, if written in Running Script would link on to the final horizontal.

1	2	3	4
5	**6**	**7**	**8**
9	**10**	**11**	**12**
13	**14**	**15**	**16**
17	**18**	**19**	**20**
21	**22**	**23**	

12 Baby
Yīng ér

01–15 16–23

Yīng: keep the two upper characters ("shells") central to the "female" symbol below, which has a wide supporting horizontal stroke.

13 Daughter
Nǚ ér

01–03 04–11

"Nǚ" means "female" and "ér" is someone "dear" or "little."

The sweeping strokes of each character can be lengthened to create a feeling of balance.

1	2	3	4
5	6	7	8
9	10	11	

14 Son
Ér zǐ

01–08 09–11

If you follow the step-by-step guide, you will find that all the strokes will fit and coexist comfortably in the square. The two characters occupy the whole square, so the strokes have plenty of space to show off their movements.

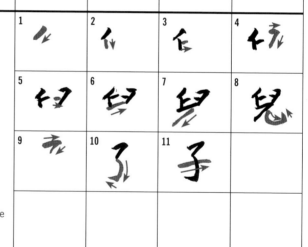

direction of stroke
current stroke
previous strokes

PEOPLE

1	2	3	4
5	6	7	8
9	10	11	12

15 Child
Hái zǐ

01–09 10–12

Hái: the series of short diagonal strokes are counterbalanced by the top dot and the bottom opposing diagonal. Keep this character in proportion to the zǐ character to its left and right.

1	2	3	4
5	6	7	8
9	10		

16 Grandchild
Sūn

Again, zǐ is seen on the left side of this character. If you wish to indicate a maternal grandchild, wài should be added in front, as in wài sūn.

17 Fraternal niece
Zhí nǚ

01–09 10–12

Different names are used for relatives on each side of the family. Here, the brother's side of the family is listed.

As a niece is female, you will see that nǚ ("female") resides on the left side of the first character. The other side is zhí, which means "arrive".

1	2	3	4
5	6	7	8
9	10	11	12

18 Fraternal nephew

Zhí zǐ

01–08 09–11

When referring to a male, rén ("people") is written at its left side, instead of the nǚ ("female") that is found in the character for niece.

1	2	3	4
5	6	7	8
9	10	11	

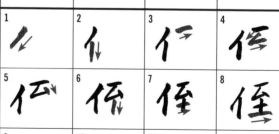

 direction of stroke
current stroke
previous strokes

1	2	3	4

5	6	7	8

19 Paternal aunt
Gū

Gū means a father's sister. An aunt can also be addressed as gū gū. The gender explanation (nǔ, "female") is written at the left side of the character. The right side, gū, is the element for pronunciation. Gū has a cross on top of kou ("mouth"), in which the latter means "learn all that comes from the past."

1	2	3	4

5	6	7	8

9	10	11

20 Maternal aunt
Yí

In the example here, yí means "mother's sister." The left side of yí has a nǔ ("female") to indicate the gender. The sound element lies with the right side yí, which means "safe."

Mā means "mother." Yí mā is the way to address your mother's older sister; her younger sister should be addressed as yí.

21 Uncle (father's brother)
Shū bó

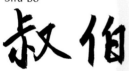

Shū: be aware of the line quality of strokes and their variety; notice fine lines and swelling strokes.

Bó: the strokes of the "person" symbol are repeated in the left-hand character before being built up into a separate character.

1	2	3	4
5	6	7	8
9	10	11	12
13	14	15	

22 Uncle (mother's brother)
Jiù

Jiù has three components. On its top is the "head." The middle and bottom parts form the character nán ("male"), which has tian ("field") on top of li ("strength").

1	2	3	4
5	6	7	8
9	10	11	12
13			

direction of stroke
current stroke
previous strokes

1	2	3	4
5	6	7	8
9	10	11	12
13	14	15	16
17			

23 Maternal nephew

Wài shēng

外锡

01–05 06–17

Shēng: step 16 is a sweeping stroke with a flick that invites the eye to complete the triangle, but that is then bisected by the final diagonal. Observe the relative proportions of all the elements.

1	2	3	4
5	6	7	8
9	10	11	12
13	14	15	16
17	18	19	20

24 Maternal niece

Wài shēng nǚ

外锡女

01–05 06–17 18–20

The first character wài has two elements: the first element extends to the left while the second stands firm, with an arm stretching out to the right to balance the character.

25 Cousin
Biǎo gē

Biǎo: notice that the lower vertical is not in line with the upper one; this allows space to balance the final right-hand strokes, which finish with a dramatic diagonal sweep.

1	2	3	4
5	6	7	8

26 Godparents
Jiào fù mǔ

01–11 12–15 16–20

Jiào means "teach" and fù mǔ means "parents."

Jiào has two parts. The left side combines xiao, meaning "piety," with zi, meaning "young child." Its right side means "to softly strike with a stick." All these relate to the meaning of "teach."

The characters fù and mǔ have already been covered (see page 82).

1	2	3	4
5	6	7	8
9	10	11	12
13	14	15	16
17	18	19	20

direction of stroke
current stroke
previous strokes

1	2	3	4
5	6	7	8
9	10	11	12
13	14	15	16

27 Teacher
Lǎo shī

01–06 7–16

Lǎo: the placing of strokes in steps 5–6 is a counterbalancing exercise dictated by the long, separating diagonal.

Shī: the final down stroke of the right-hand character extends below its neighbor, with its crossbar above the center.

1	2	3	4
5	6	7	8
9	10	11	12
13	14	15	16
17	18	19	20
21			

28 Student
Xué shēng

01–16 17–21

Xué: use fine brushstrokes to assemble all the detail in the top of this character, which would be topheavy if the proportions of the cover and its "child" were not large enough.

29 Neighbor
Lín jū

鄰居

01–15 16–23

Lín means "close by" or "next to," and jū means "residence."

Chinese characters are varied, combining different elements. Some of them can be simple with just a few strokes, while others may have many strokes joined together. Lín has many more strokes on the left side than on the right. Allow enough space on the left side so that it is not cramped.

30 Best friend
Zhī jǐ

知己

01–08 09–11

The first character, zhī, means "to know."

Jǐ, which has only three strokes, means "self" therefore, a person who knows you as well as him- or herself is your best friend.

direction of stroke
current stroke
previous strokes

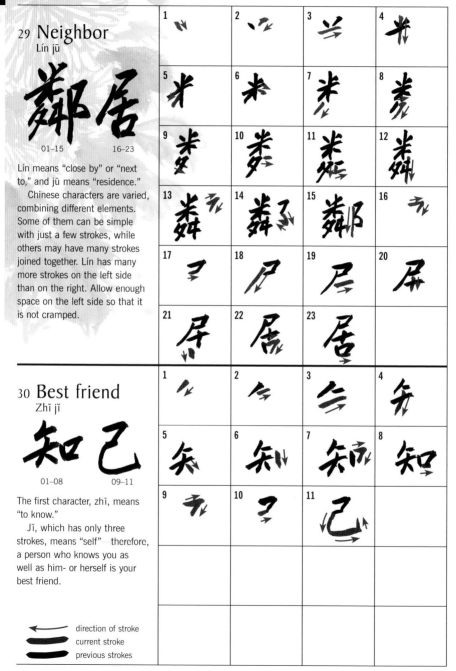

1	2	3	4
5	6	7	8
9	10	11	12
13			

31 Lover
Qíng rén

01–11 12–13

Qíng; keep the middle of the three horizontals narrowest (steps 4–7). Do not close the rectangle at the bottom by overdoing the flick.

1	2	3	4
5	6	7	8
9	10	11	12

32 Friend
Péng yǒu

01–08 09–12

Yǒu: ensure that the final extending stroke is strong and swells, then tapers at the end.

Chinese zodiac

Pictograms of animals are generally constructed according to their shapes, and each represents a Chinese zodiac sign. The easy step-by-step instructions take you through even the most complicated forms.

1 Rat
Shǔ

鼠

This character is symmetrical until the final extended flourish, which perhaps resembles a rat's tail!

1	2	3	4
5	6	7	8
9	10	11	12
13			

2 Ox
Niú

牛

Niú involves only four steps. Be sure to direct your brush firmly and decisively onto the paper and to direct energy to the end of the stroke.

1	2	3	4

direction of stroke
current stroke
previous strokes

1	2	3	4
5	6	7	8

3 Tiger
Hǔ

You can see the strength and determination of the tiger in this character. Extend the last stroke in step 8 to balance the whole character.

1	2	3	4
5	6	7	8
9			

4 Rabbit
Tù

This peace-loving creature is depicted by the character tù. A strong back leg is added in step 8. Don't forget to add a dot in step 9.

5 Dragon
Lóng

You can almost see the dragon in this character, lóng, which seems to have legs, horns, and tails flying all over the place. The extended horizontal stroke on the left is balanced by the long curved stroke on the bottom right, which is weighted down with three more strokes.

1	2	3	4
5	6	7	8
9	10	11	12
13	14	15	16
17	18		

6 Snake
Shé

The right-hand character is larger than the left, and has a more dynamic shape with the final curve.

1	2	3	4
5	6	7	8
9	10	11	

direction of stroke
current stroke
previous strokes

1 小	**2** 广	**3** 广	**4** 戸
5 馬	**6** 馬	**7** 馬	**8** 馬
9 馬	**10** 馬	**11** 馬	

7 Horse
Mǎ

The character mǎ originated from a pictogram; the legs of the horse are still discernible here, though they have now been reduced to four dots. Chinese calligraphers try to create subtle differences within the strokes without causing too much disturbance. Try to get the dots to greet each other, to create a feeling of continuity.

1 丷	**2** 丷	**3** 丷	**4** 半
5 兰	**6** 羊		

8 Ram
Yáng

The ram is a gentle, sensitive animal. The two horns depicted in the character are written downward; the last horizontal stroke is the longest, to balance the figure.

9 Monkey
Hóu

This intelligent character is agile in its movements. The right part of the character has a man on its left with bows and arrows at the bottom of the tree, ready to shoot. The left side often appears in characters relating to animals.

1	2	3	4
5	6	7	8
9	10	11	12
13			

10 Rooster
Jī

The left component of this character, according to the old form, means "big stomach" and its right side means "bird." The central upright strokes separate and balance the busier left-hand character, and are echoed more gently in the right-hand element.

1	2	3	4
5	6	7	8
9	10	11	12
13	14	15	16
17	18		

direction of stroke
current stroke
previous strokes

1	2	3	4
5	6	7	8

11 Dog
Gǒu

The dynamic diagonal strokes are complemented by the curved strokes in this lively character.

1	2	3	4
5	6	7	8
9	10	11	12
13	14	15	

12 Pig
Zhū

This character has two parts; its left side indicates "pig," while its right side gives the phonetics of the character. Remember that you are writing one character, not two. Shorten the strokes on the left side so that those on the right side can be positioned close by.

Greetings and Salutations

Formal and informal terms of address and greeting are invaluable in calligraphy, as well most other forms of communication. They will occur in letters, scrolls, and poetry to pass on sentiment, pleasure, or excitement.

1 Good morning
Zǎo ān

01–06 07–12

Zǎo means "morning" and ān means "settled," "comfort," or "well." The horizontal line can be lengthened to balance the whole character.

2 Good day
Jīn tiān hǎo

01–05 06–12

The first two characters both have strong diagonals which give liveliness to the writing; pay attention to the end of the stroke to obtain a fine point.

direction of stroke
current stroke
previous strokes

1	2	3	4
5	6	7	8
9	10	11	12
13			

3 Hello
Nǐ hǎo

你 好

01–07　　　08–13

The two characters each have two parts, all with similar numbers of strokes, so this should not present problems with balancing proportions.

1	2	3	4
5	6	7	8
9	10	11	12
13	14	15	16
17	18	19	20
21	22	23	24
25	26		

4 How are you?
Nǐ hǎo má

你 好 嗎 ?

01–07　　08–13　　14–26

When you enquire about someone's well-being, Nǐ hǎo má? ("How are you?") is used to express your concern.

Má has a "mouth'" (kou) on its left side and "horse" (má) on its right side. This exclamation is used as a means of expressing a question. Kou can be written a little higher, leaving enough room for the four dots at the bottom.

5 Good afternoon
Wǔ ān

01–04 05–12

When writing wǔ, try to press the brush downward on the paper and carry it through to the end of the stroke.

An has a nǔ ("female") under its roof. Spread the two horizontal strokes outward to make the character well balanced.

1	2	3	4
5	6	7	8
9	10	11	12

6 Good night
Wǎn ān

01–12 13–20

The Chinese say wǎn ān when they retire to bed. An is a greeting of the day and wǎn means "night."

Wǎn has two parts. On its left side, ri, which is the smaller part of the character, indicates "day." On its right side, the emphasis is on the lower part of the character.

1	2	3	4
5	6	7	8
9	10	11	12
13	14	15	16
17	18	19	20

direction of stroke
current stroke
previous strokes

1	2	3	4
5	6	7	8
9	10	11	12
13	14	15	16
17	18	19	20
21	22	23	24
25	26	27	28
29	30	31	32
33	34	35	36
37			

7 Dear

Qìng ài de

親愛的

01–16 17–29 30–37

Qìng ài de is an expression of affection and can be followed by the name of anyone you would like to refer to, such as father, mother, son, or daughter.

The first character, qìng, means "affectionate," or "close." The two parts in this character have equal prominence. Its right side jian ("look") gazes at the left side with affection. Enjoy the last two dynamic strokes, and that final flick.

The second character, ài, includes xīn ("heart") in the middle. The wide curved horizontal in step 22 shelters the "heart" symbol and its width is balanced below by the final diagonal strokes.

De is often used to denote possession, and can be used with any pronouns and nouns.

8 Please
Qĭng

Qĭng is used as an invitation to someone to sit, eat, or drink. On its left side, yán means "conversation," "language," or "literature." On its right side, qĭng means "green," which gives the character its sound. Pay attention to the relative widths of the horizontals; those in the middle are shorter than the upper and lower ones.

1	2	3	4
5	6	7	8
9	10	11	12
13	14	15	

9 Best wishes
Zhù fú

01–09 10–22

Both characters have the same elements on their left side to indicate the meaning of prayers or wishes. In order to make the characters look artistic, the writing of the two elements on the left side can be different. Here, zhù has been written using Xin Shu (Running Script), in which the strokes are linked, while the other side is written formally using the stroke-by-stroke Kai Shu style.

direction of stroke
current stroke
previous strokes

1	2	3	4
5	6	7	8
9	10	11	12
13	14	15	16
17	18	19	20
21	22		

1	2	3	4
5	6	7	8
9	10	11	12
13	14	15	16
17			

10 It's great!
Liǎo bù qi

01–03 04–07 08–17

There are several ways to exclaim "It's great!" and Liǎo bù qi is one of them. Liǎo means "finish" and has only two strokes. Bù has the negative meaning "no."

Qi means "up," with zou ("run") on its left side and ji ("self") supported in its arm on the right. Make the diagonal (step 14) long, and swelling in width then tapering at the end.

1	2	3	4
5	6	7	8
9	10	11	12
13	14	15	16
17	18		

11 Take care
Bǎo zhòng

01–09 10–18

Bǎo means "protect" and zhòng means "important." When Chinese people say farewell to each other, Bǎo zhòng expresses their concern and consideration toward others.

Bǎo: spread the lower strokes (steps 8 and 9) so they radiate out and balance the form above the horizontal.

Zhòng: the vertical stroke supports the whole structure and reaches from top horizontal to base line.

12 Cheers!

Zhù hǎo

01–09 10–15

Zhù hǎo means "Wish you well!" Keep the writing lively and balanced in proportions; explore the running form that makes the final two strokes (steps 14–15) merge into one.

1	2	3	4
5	6	7	8
9	10	11	12
13	14	15	

13 Cheers!

Gān bēi

01–11 12–19

This is a more informal salutation. Once you have practiced the stroke, try this in Xing Shu (Running Script) to make the characters as lively and cheerful as their meaning. Gān bēi means "dry your glass!"

1	2	3	4
5	6	7	8
9	10	11	12
13	14	15	16
17	18	19	

direction of stroke
current stroke
previous strokes

1	2	3	4
5	6	7	8
9	10	11	12
13			

14 Good-bye
Zài jiàn

01–06 07–13

Zaì jiàn literally means "See you again." The first character, zaì ("again"), has three horizontal strokes, of which the bottom is the longest in order to balance the weight of the others.

Jiàn means "see." The top component means "eye," which sits on top of a "person"—the two sweeping strokes below.

1	2	3	4
5	6	7	8
9	10	11	12
13	14	15	16
17	18		

15 Good
Hěn hǎo

1–10 11–18

Hǎo means "good." It includes nǚ ("daughter") and zǐ ("son"). When two elements appear in one character, make sure you allow enough room for both to exist harmoniously together. Hěn emphasizes the meaning—so hěn hǎo means "very good."

16 Thank You

Xiè xiè nǐ

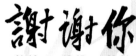

01–16 17–27 28–34

Xiè is repeated to emphasize gratitude. In Chinese calligraphy, the shape of the character can be altered slightly when the same characters appear side by side.

In the example shown here, see how the strokes on the left side of the second xiè are linked to the strokes on the right side, with the flick of the stroke linked to the last dot.

1	2	3	4
5	6	7	8
9	10	11	12
13	14	15	16
17	18	19	20
21	22	23	24
25	26	27	28
29	30	31	32
33	34		

direction of stroke
current stroke
previous strokes

17 Visit
Tàn wàng

探 望
01–11 12–22

Tàn means "to explore" and wàng means "look." We use this phrase for visiting friends or relatives.

18 Haven't seen you for a long time
Hǎo jiǔ bù jiàn

好久不見
01–06 07–09 10–13 14–20

Hǎo jiǔ bù jiàn is said when two friends haven't seen each other for a long time. Hǎo jiǔ means "a long time," bù means "no" or "not" and jiàn means "see." When these are put together, it means just that.

Celebrations

The Chinese often write proverbs, idioms, or poetry as brushwork to celebrate special occasions. The list provided below relates to happy occasions. Choose from them to enhance your own celebrations. Take pleasure in the creative process, but always remember to use the basic brushwork techniques.

ı Happy Birthday

Kuài lè shēng rì

生日快樂

01–05 06–09 10–16 17–31

Kuài lè means "happy" and shēng rì means "birthday"; rì means "day."

The last character, lè, has many strokes. The top and bottom parts are equally important, although the bottom part has fewer strokes. The horizontal stroke in the middle should be long enough to support the top part comfortably.

1	2	3	4
5	6	7	8
9	10	11	12
13	14	15	16
17	18	19	20
21	22	23	24
25	26	27	28
29	30	31	

direction of stroke
current stroke
previous strokes

2 Celebrate

Qìng zhù

01–14 15–23

Qìng has fourteen strokes, which should be spaced with care. In the middle of qìng is the character xīn ("heart") to express that it is celebrated with love.

Zhù has two components. Its left side is often used in combination with other characters to signify ceremonies and prayers.

3 Birth

Dàn shēng

01–14 15–19

Dàn means "birth" and shēng means "life."

The character shēng contains three horizontal strokes, with the middle stroke being the shortest. When writing in Xing Shu (Running Script), link the last two horizontal strokes with a flowing movement, carrying the brush with a sweeping move to form another stroke.

4 Anniversary

Zhōu nián jì niàn

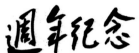

01–11 12–17 18–26 27–34

Zhōu nián jì niàn means "annual remembrance."

Although the second and fourth characters have the same pronunciation, they have different meanings and are written differently. You will find that this is true of many Chinese characters.

Note how, on the left side of the third character, jì, the three dots at the bottom are linked together. In Running Script (Xing Shu), dots can be linked together to express the significance of the characters.

1	2	3	4
5	6	7	8
9	10	11	12
13	14	15	16
17	18	19	20
21	22	23	24
25	26	27	28
29	30	31	32
33	34		

direction of stroke
current stroke
previous strokes

1	2	3	4
5	6	7	8
9	10	11	12
13	14	15	16
17	18	19	20
21	22	23	

5 Marriage
Jié hūn

结 婚

01–12 13–23

The character jié, meaning "tie," has "silk" on its left side and jii on its right side to give its pronunciation.

There is a nǔ ("female") on the left side of the second character, hūn, giving it a feminine significance. This "female" element needs to be balanced in proportion to the more complex right-hand units.

1	2	3	4
5	6	7	8
9	10	11	12
13	14	15	16
17	18	19	20

6 Engagement
Dìng hūn

訂 婚

01–09 10–20

Dìng: keep the proportions balanced, especially the relative lengths of the horizontal strokes, stabilized by the strong vertical.

Hūn: notice that this second character is the same as in "marriage," above, so write it again as described.

DIRECTORY OF CHINESE CHARACTERS

7 Fun

Qù zǒu

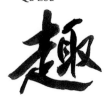

This is an interesting character, with two parts close to each other. One part seems to stretch out to hug the other.

When you are writing the left side, make sure to extend the downward stroke far to the right so that qù can be placed on top.

1	2	3	4
5	6	7	8
9	10	11	12
13	14	15	

8 Bride

Xīn niáng

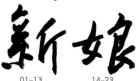

01–13 14–23

Xīn niáng means, literally, "new wife." Note that the left side of niáng is nǚ ("female").

Xīn: in the left-hand character, the middle of the three horizontal lines should be the smallest, for balance.

Niáng: the right-hand part of this character is more complex to build up than the "female" element, so allow plenty of vertical space.

1	2	3	4
5	6	7	8
9	10	11	12
13	14	15	16
17	18	19	20
21	22	23	

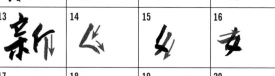

 direction of stroke
current stroke
previous strokes

1	**2**	**3**	**4**
5	**6**	**7**	**8**
9	**10**	**11**	**12**
13	**14**	**15**	**16**
17	**18**	**19**	**20**
21	**22**	**23**	**24**
25	**26**	**27**	**28**

9 Marriage Made in Heaven

Jiā ǒu tiān chéng

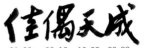

01–08 09–18 19–22 23–28

This proverb literally means, "the bride and her groom are the best couple made in heaven."

Jiā ǒu tiān chéng can be written vertically or horizontally. When this proverb is written in a greeting card, the space and shape of the characters must be carefully considered before you take up your brush. Are you going to write it in a formal way, or with some artistic expression?

Make sure that the ink is not too pale, the strokes are not too thin, and that the parts are all in equal proportion.

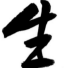

10 Birthday
Shēng rì

生 日

01–05 06–09

The character shēng means "birth" or "grow." The second character, rì, means "day" or "sun."

1	2	3	4
5	6	7	8
9			

11 Wedding
Hūn lǐ

婚 禮

01–11 12–28

Hūn lǐ means "ceremony of a marriage." Hūn has a nǔ ("female") on the left side and the sounding character hùn on the right side. The second character, lǐ, means "ceremony," its left side signifying formality.

Lǐ: use the fine tip of the brush to make the short multiple strokes of the right-hand element. The long baseline supports the structure.

Both these characters have complicated strokes. The more strokes there are, the shorter they must be to allow space for each other.

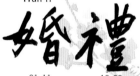

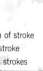 direction of stroke
current stroke
previous strokes

1	2	3	4
5	6	7	8
9	10	11	12
13	14	15	16
17	18	19	20
21	22	23	24
25	26	27	28

1	2	3	4
5	6	7	8
9	10	11	12
13	14	15	16

12 Enjoy
Xiăng shòu

01–08 09–16

The bottom horizontal stroke of xiăng should be long enough to give stability to the whole character. Shòu means "to accept" or "to take on." Its bottom part supports the whole character, so the two strokes can be written outward to give strength.

1	2	3	4
5	6	7	8
9	10	11	12
13	14	15	16
17	18	19	20
21	22		

13 Groom
Xīn láng

01–13 14–22

Xīn láng literally means "new husband."

Xīn and láng have two parts of equal importance. Each has a vertical stroke on the right side, making the character look well balanced.

14 Congratulations
Zhù hè

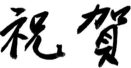

01–09　　　10–20

Zhù has two equal parts; the left side indicates a ceremony or wishes. The strokes in the center are shorter than those on the outside, to enable the two parts to be positioned close together.

The second character, hè, has both upper and lower parts; the lower half, which is bei ("shell"), acts as a support for the whole character.

1	2	3	4
5	6	7	8
9	10	11	12
13	14	15	16
17	18	19	20

15 Graduation
Bì yè

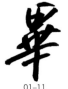

01–11　　　12–23

Bì means "finished" and yè is "study" or "business."

Both have a similar upright shape, with a central vertical stroke that stabilizes the whole character.

To make the character look upright, you need to continue the qì—the flow of spirit—to the very end of the vertical stroke.

1	2	3	4
5	6	7	8
9	10	11	12
13	14	15	16
17	18	19	20
21	22	23	

direction of stroke
current stroke
previous strokes

1	2	3	4	
5	6	7	8	
9	10	11	12	
13	14	15	16	
17	18	19	20	
21	22	23	24	
25	26	27	28	
29	30	31	32	
33	34	35	36	
37	38	39	40	
41	42	43	44	45

16 Good Business

Shēng yì xīng lóng

生意興隆

01–05 06–18 19–34 35–45

When a new business is started, the proprietor is congratulated with a greeting such as "Shēng yì xīng lóng." Shēng yì means "business" and xīng lóng means "prosperous."

Xīng may be unfamiliar; it has a complexity of strokes above the horizontal, with just two dots below; spread these to balance the character.

The fun of Chinese calligraphy lies in the different shapes of the characters, which you can express freely with the acquired stroke technique. Following the step-by-step stroke order, you will find that it is very interesting and not difficult to get the characters right. Have a go!

17 Happy New Year

Xīn nián kuài lè

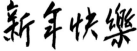

01–13 14–19 20–26 27–41

This phrase can be written vertically or horizontally, depending on the space available. In the example shown here, the characters have been written using Xing Shu (Running Script); some bold strokes are linked by thin thread-like strokes to produce a flowing, expressive style.

direction of stroke
current stroke
previous strokes

新年快樂 CELEBRATIONS

1	2	3	4
5	6	7	8
9	10	11	12
13	14	15	16
17	18	19	20
21	22	23	24
25	26	27	28
29	30	31	32
33	34	35	36
37	38	39	40
41	42	43	44

18 Best Wishes for Prosperity

Gōng xǐ fā cái

恭喜發財

01–10 11–22 23–35 36–44

During the Chinese New Year period, people put their hands together to wish each other gōng xǐ fā cái ("wealth and prosperity").

It is possible to make characters with numerous strokes appear grand and graceful. To prevent them from looking overcrowded, add some thinner strokes to lighten them up.

Gōng ("together") has a heart (xīn) underneath it, which gives the sound. It means "to congratulate with love."

Xǐ means "happiness," and shows a mouth laughing.

Fā means "to expand and prosper," with many strokes crowded neatly underneath it; use a light touch to fit them all in. The arrow on its left side indicates "to shoot" or "to fire."

Cái has a shell on its left side which refers to the time when shells were used as currency. The sound "cái" is given by the word on its right side. This character has a simpler construction than the others in this phrase, allowing you to focus on balancing stroke weights.

19 Surprise

Jīng qí

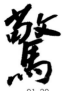

01–20 21–28

Make the middle part of Jīng smaller than the top and bottom parts to balance the character.

When you write the second character, qí, you can lengthen the horizontal line across the middle part to support and balance the whole character.

1	2	3	4
5	6	7	8
9	10	11	12
13	14	15	16
17	18	19	20
21	22	23	24
25	26	27	28

20 Retirement

Tuì xiū

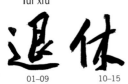

01–09 10–15

The final stroke of each character sweeps downward in order to create balance.

direction of stroke
current stroke
previous strokes

1	2	3	4
5	6	7	8
9	10	11	12
13	14	15	

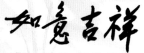

汉仪 CELEBRATIONS

1	2	3	4
5	6	7	8
9	10	11	12
13	14	15	16
17	18	19	20
21	22	23	24
25	26	27	28
29	30	31	32
33	34	35	

21 Best Wishes and Best of Luck

Rú yì jí xiáng

如意吉祥

01–06 07–19 20–25 26–35

This is the traditional New Year greeting; it is appropriate to any happy occasion.

Rú yì means "best wishes," and the phrase can be used on its own. In the character yì, the top part means "sound" (yin), with a heart (xīn) below it—so the character means "the voice of your heart." Yì on its own means "wish."

The characters jí xiáng can also be used on their own, to mean "good luck." All these characters have many strokes; concentrate on your brush technique to obtain sensitive marks by thinking about pressure and fine lines.

22 Welcome

Huān yíng

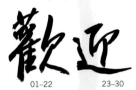

01–22 23–30

A host says "Huǎn yíng" when welcoming guests. Huān means "happy" and yíng means "to receive your arrival."

The many strokes on the left side of huān are balanced by the simplicity of the right side. Of course, too much difference in size can spoil the proportion of the whole character. Remember to place the two parts close together.

Some Xing Shu (Running Script) has been used here to soften the character.

direction of stroke
current stroke
previous strokes

1	2	3	4
5	6	7	8
9	10	11	12
13	14	15	16
17	18	19	20
21	22	23	24
25			

23 Gift

Lǐ wù

禮 物

01–17 18–25

Lǐ wù, which means "a present for the ceremony," can be said at any special occasion.

The left side of lǐ indicates formality. Take care not to let the top part of the right-hand character overwhelm the lower elements.

Wù means "item." Be generous with the curve in stroke 23 so that there is space to fit the final strokes inside.

1	2	3	4
5	6	7	8
9	10	11	12
13	14	15	

24 Baptism

Jìn lǐ

浸 礼

01–10 11–15

Lǐ is the same character that was used in "gift" (lǐ wù), but with far fewer strokes. The simplified form has been used in this example, where the right side of the traditional writing of lǐ has been simplified into one stroke.

25 Rejoice
Xǐ lè

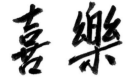

01–12 13–27

Xǐ is a tall and thin character with a long horizontal stroke balanced across it.

In lè, the three small top parts share equal spaces, while the bottom part of the character supports the upper by having two short strokes on either side.

1	2	3	4
5	6	7	8
9	10	11	12
13	14	15	16
17	18	19	20
21	22	23	24
25	26	27	

26 Christening
Xǐ lǐ

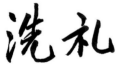

01–09 10–14

Xǐ means "wash." The character has three dots (short strokes) on its left side to indicate water. Lǐ means "ceremony."

— direction of stroke
— current stroke
— previous strokes

1	2	3	4
5	6	7	8
9	10	11	12
13	14		

1	**2**	**3**	**4**
5	**6**	**7**	**8**
9	**10**	**11**	**12**
13	**14**	**15**	**16**
17	**18**	**19**	**20**
21	**22**	**23**	**24**
25	**26**	**27**	**28**
29	**30**	**31**	**32**
33	**34**	**35**	**36**
37	**38**	**39**	

27 Hallelujah

Zàn měi zhǔ

讚 美 主

01–25 26–34 35–39

Zàn měi zhǔ means "Praise the lord." Zàn, meaning "praise," has several strokes on its right side; its left side is related to speech.

The character měi means "beauty" and is supported by two sweeping strokes on either side.

Zhǔ means "god" or "master." It is a simple character with a vertical stroke holding down the three horizontal strokes.

祝礼 CELEBRATIONS

Festivals

You will find traditional Chinese holidays here, like Grave-tending Day and the Dragon Boat Festival. Also included are some religious festivals, which are celebrated all around the globe.

1 Dragon Boat Festival

Duān wǔ jié

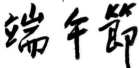

01–14 15–18 19–32

In the lunar calendar, May 5 is the festival celebrating the life of Qu Yuan, who died because his country, Chu, was taken over by Qin. After his death, people threw rice dumplings into the river from their row boats to stop the fish from disturbing his body.

The left side of the character duān is smaller than the right side. In order to make the character look attractive, tilt the left side slightly, so that it is leaning toward the right.

1	2	3	4
5	6	7	8
9	10	11	12
13	14	15	16
17	18	19	20
21	22	23	24
25	26	27	28
29	30	31	32

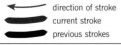

direction of stroke
current stroke
previous strokes

1	2	3	4
5	6	7	8
9	10	11	12
13	14	15	16
17	18	19	

2 New Year
Xīn niàn

01–13 14–19

Xīn means "new" and niàn is "year." Xīn consists of two parts of equal importance. Within the three horizontal strokes on the left, the middle stroke should be the shortest.

Niàn has a vertical stroke that must be executed properly: do not lift the brush up too soon, otherwise the "mouse's tail" will not be completed.

1	2	3	4
5	6	7	8
9	10	11	12
13	14	15	16
17	18	19	20
21	22		

3 Chinese New Year
Chūn jié

01–09 10–22

Chūn is "spring" and jié is "festival," or "section" (of bamboo). The top part, jié, indicates "bamboo," while the lower part gives the sound "ji."

Chūn: make stroke steps 4–5 lively and strong.

Jié: note that the lower two parts of this character are not in line; the final downward stroke supports the structure.

4 Valentine's Day

Qíng rén jiē

情人節

01–11 12–13 14–28

There are three characters for this "Festival for Lovers."

Qíng ("love") is felt from the heart, so the left side of the character features xīn ("heart"), while the right side gives the sound.

Rén means "people." It consists of two strokes, the one on the right being a "duck's tail." Press the brush firmly downward to form a triangular shape and then move the brush to the right to form a point.

1	2	3	4
5	6	7	8
9	10	11	12
13	14	15	16
17	18	19	20
21	22	23	24
25	26	27	28

direction of stroke
current stroke
previous strokes

1	2	3	4
5	6	7	8
9	10	11	12
13	14	15	16
17	18	19	20
21	22	23	24
25	26	27	28
29	30	31	32

5 Grave-tending Day

Qīng míng jié

1–11 12–19 20–32

This festival is set in springtime for relatives to tend their ancestors' graves.

The two short strokes at the bottom on the left side of qīng are linked as if they are one stroke. This technique, in which one stroke continues into the next, giving the script a flowing appearance, is known as Xing Shu (Running Script).

6 Good Friday
Shòu lán jiē

01–08 09–27 28–40

Shòu lán jiē is the day to remember the suffering of Jesus.

The middle character lán has two parts, in which both the left and right sides are equally important.

Shòu: the strong diagonals are a feature of this character.

Lán: the complexity of strokes requires a light touch with the brush for both halves.

direction of stroke
current stroke
previous strokes

1	**2**	**3**	**4**
5	**6**	**7**	**8**
9	**10**	**11**	**12**
13	**14**	**15**	**16**
17	**18**	**19**	**20**
21	**22**	**23**	**24**
25	**26**	**27**	**28**
29	**30**	**31**	**32**
33	**34**	**35**	**36**

7 Easter Day
Fù huó jiē

復活節

01–13 14–22 23–36

Fù means "return" and huó means "alive"—so fù huó jiē ("Easter Day") means "resurrection."

When you write three characters in a row, as here, the middle character should be slightly smaller to make room for the other characters.

8 Mother's Day

Mǔ Qīn jiē

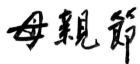

01–05 06–20 21–33

In the character mǔ, the central horizontal stroke is written across two shorter strokes. It stretches out like a long arm to balance the whole character.

1	2	3	4
5	6	7	8
9	10	11	12
13	14	15	16
17	18	19	20
21	22	23	24
25	26	27	28
29	30	31	32
33			

direction of stroke
current stroke
previous strokes

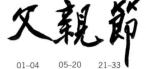

FESTIVALS

9 Father's Day
Fù qīn jiē

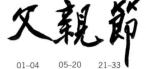

01–04 05–20 21–33

Fù has far fewer strokes than qīn. Sometimes you will find that combinations like this can lighten the formality of the appearance of the whole line, although you should make sure that fù is written with the same weight as qīn.

10 Moon Festival
Zhōng qiū jiē

中秋節

01–04 05–13 14–26

August 15 in the lunar calendar is the Mid-Fall Festival (zhōng qiū), which people celebrate by lighting beautiful lanterns and eating moon cakes in remembrance of Chang E, who lives in the moon with her little rabbit.

The character for "mid" is zhōng, which is also used to indicate China. (Zhōng guó is the "middle kingdom.") The vertical stroke that goes down the center of the character can be even longer than shown here, depending on the space available.

Qiū means "fall," which is the season for harvesting and when the air is dry. Hence, "crop" is on the left side and "fire" is on its right.

direction of stroke
current stroke
previous strokes

1	2	3	4
5	6	7	8
9	10	11	12
13	14	15	16
17	18	19	20
21	22	23	24
25	26	27	28
29	30	31	32
33	34	35	36

11 Thanksgiving Day
Gān ēn jié

01–13 14–23 24–36

Gān means "feeling" or "thank you" and ēn means "kindness." Both characters have a "heart" (xīn) at the bottom to indicate the significance of feelings of love.

The long slanting stroke to the right in gān has to allow space for xīn, so make sure that the top half of the character does not press down on the lower half.

En has two parts, with xīn bearing the weight of the top part, yin.

12 Hanukkah

Yóu tài shèng jiē

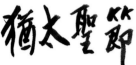

猶太聖節

01–12 13–16 17–29 30–43

This festival means "Jewish Holy Day" and consists of four characters. Yóu tài means "Jewish" and shèng jiē means "holy festival."

Yóu and shèng are the most complex characters; use a light brush technique to fit all the strokes into the space, and pay attention to the overall balance of sizes.

1	2	3	4
5	6	7	8
9	10	11	12
13	14	15	16
17	18	19	20
21	22	23	24
25	26	27	28
29	30	31	32
33	34	35	36
37	38	39	40
41	42	43	

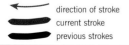

direction of stroke
current stroke
previous strokes

143

褚大學智 FESTIVALS

1	2	3	4
5	6	7	8
9	10	11	12
13	14	15	16
17	18	19	20
21	22	23	24
25	26	27	28
29	30	31	32
33	34	35	36
37	38	39	40
41			

13 Christmas Day
Shèng dàn jiē

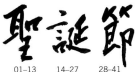

聖 誕 節

01–13 14–27 28–41

In the past, shèng dàn jiē ("Christmas") was celebrated mainly in the West, but now the birth of Jesus is celebrated all over the world. Shèng means "holy" and dàn means "birth."

Shèng dàn jiē has three characters in a row, so take care to leave sufficient space between them. The lower part of the first character, shèng, has three horizontal strokes and a vertical stroke straight down. The vertical stroke needs to be in the middle of the character to support the top part comfortably and securely.

The second character, dàn, has two parts, the left side of which takes up less space than the right. You can emphasize the stroke's movement toward the right if you wish.

Affirmations

You may notice that sometimes more than one character is used to represent an expression. Each character can be combined with others to produce a range of meanings, extending the vocabulary. Look at the following list and see if you can spot the same character combining with others in different expressions.

1 Freedom
Zì yóu

01–06 07–11

Zì means "self" and yóu means "reason" or "follow." Freedom, therefore, is a matter of following one's own will.

1	2	3	4
5	6	7	8
9	10	11	

2 Growth
Shēng zhǎng

01–05 06–13

These characters have "linking threads" (brush movement between strokes) between steps 4–5 and 6–7. These threads give a continuous flow of movement in writing, so that the piece has a wonderful feeling of growth.

1	2	3	4
5	6	7	8
9	10	11	12
13			

direction of stroke
current stroke
previous strokes

1	2	3	4
5	6	7	8
9	10	11	12
13	14	15	16
17	18	19	20
21	22	23	

3 Smile

Wēi xiào

01–13 14–23

In Chinese, wēi means "little" or "slight," and xiào means "laugh"—so a smile is a "gentle laugh."

Wei has some complicated components. The left side, with two slanting strokes to the left, indicates "small steps." Write the middle component shorter and extend the right element with a stroke sweeping to the right.

Xiào: extend the final strokes to either side for exuberance, with a generous sweep to the right.

1	2	3	4
5	6	7	8
9	10		

4 Laugh

Xiào

Xiào resembles a happy, lively face! Don't be afraid to show its exuberance by extending its strokes to either side, although the right downward stroke should be longer than the left stroke, which is vigorous and smart.

5 Health

Jiàn kāng

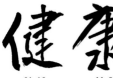

01–10 11–21

Jiàn has two components. The left side means "person," and the right side gives the sound jiàn. The latter part has five horizontal strokes, the second of which should be the longest.

Kāng: as with Jiàn, make the second horizontal the longest of the three. The vertical stroke must be long enough to anchor the final lively diagonals.

1	2	3	4
5	6	7	8
9	10	11	12
13	14	15	16
17	18	19	20
21			

6 Breathe

Hū xī

01–08 09–15

Both hū and xī have a kou ("mouth") residing on their left sides. The other parts give the sound of the characters.

In hū, the vertical stroke is the center of gravity. The other character has the exuberance of the protruding strokes.

1	2	3	4
5	6	7	8
9	10	11	12
13	14	15	

 direction of stroke
current stroke
previous strokes

1	2	3	4
5	6	7	8
9	10	11	12
13	14	15	16
17	18	19	

7 Courage
Yǒng qì

01–09 10–19

The first character, yǒng, has the shape of lì ("strength") below its upper-sounding element, indicating that a sense of courage is needed.

Qì is the "life force" and is a word we like to use nowadays to describe "the essence of life." Its top and the curved stroke downward to its right mean "the movement of clouds." Mi ("rice") in the middle is what generates the life force.

1	2	3	4
5	6	7	8
9	10	11	12
13			

8 Love
Ài

Keep the second horizontal stroke, made in three movements, wide enough to cover the more complex structure of the middle part, xīn ("heart"; watch for this in other characters). The bottom section ends with a strong diagonal.

9 Understanding
Míng bái

01–08 09–13

Míng ("clear" or "bright") and bái ("white") combine to mean "understand."

Note that, in the example given here, some strokes are linked to form a less formal style of writing, known as Xing Shu (Running Script).

1	2	3	4
5	**6**	**7**	**8**
9	**10**	**11**	**12**
13			

10 Admiration
Yǎng mù

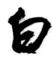

01–06 07–21

To express admiration, the characters yǎng, meaning "to look up," and mù, meaning "respect," are joined together.

Mù has a heart in the form of three dots and a central vertical stroke below the sounding element. The example shown here is in Xing Shu (Running Script).

direction of stroke
current stroke
previous strokes

1	2	3	4
5	**6**	**7**	**8**
9	**10**	**11**	**12**
13	**14**	**15**	**16**
17	**18**	**19**	**20**
21			

11 Overcome
Kè fú

01–07 08–15

Fú: balance the two parts in weight and width so that they belong together.

12 Fortune
Yùn qì

01–12 13–22

Yùn ("movement"): stabilize the form with the vertical stroke, and give the base (the "long road"—look for it elsewhere) a strong sweep.

Qì: make a generous sweep with step 16 and keep the final element, steps 17–22, tucked underneath.

DIRECTORY OF CHINESE CHARACTERS

13 Piety
Xiào

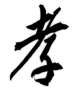

1	2	3	4
5	6	7	

Xiào: keep the parallel strokes all in proportion and make the diagonal a strong dividing stroke.

14 Play
Wán

1	2	3	4
5	6	7	8

Wang, at the left side of the character wán, has three horizontal strokes representing heaven, men, and earth. The vertical stroke depicts the emperor's power over all three.

Yuan is at its right, meaning "the beginning." Enjoy the final curved stroke, pausing before the final upward flick.

direction of stroke
current stroke
previous strokes

1	2	3	4
5	6	7	8
9	10	11	12
13	14	15	16
17			

15 Kindness
Rén cí

01–04 05–17

Rén: make a "person" (steps 1 and 2) as bold structural marks next to the number two.

Cí: fit the two columns of repeated strokes compactly under the horizontal; notice that from stage 14, "heart" (seen also in Love) is balanced underneath.

1	2	3	4
5	6	7	8
9	10	11	12
13	14	15	16
17	18	19	20
21	22	23	24

16 Harmony
Hé xié

01–08 09–24

Hé means "gentle" and xié means "stay together happily."

When you write characters that have between two and four components, make sure they are not too far apart from one another.

17 Sincere
Zhēn chēng

真 誠

01–10 11–23

Zhēn means "real" and chēng means "genuine and honest." When they are put together, they mean "sincere"—although chēng can also be used on its own, with the same meaning.

The two dots at the bottom of zhēn balance the whole form of the character.

1	2	3	4
5	6	7	8
9	10	11	12
13	14	15	16
17	18	19	20
21	22	23	

18 Righteous
Zhèng yì

正 義

01–05 06–18

Yì: note the relative lengths of the horizontals. The stabilizing verticals are curved and end in a flick.

1	2	3	4
5	6	7	8
9	10	11	12
13	14	15	16
17	18		

direction of stroke
current stroke
previous strokes

1	2	3	4
5	6	7	8
9	10	11	12
13	14		

19 Live
Shēng Huó

01–05 06–14

Shēng ("to grow"): visualize growing tips with the upper strokes, anchored in the horizontal "earth."

Huó ("alive" and "moving"): place the first three strokes below each other ("water") then look ahead if the next few strokes of the right-hand character seem disconnected.

1	2	3	4
5	6	7	8
9	10	11	12
13	14	15	16
17	18		

20 Achievement
Chéng jiù

01–06 07–18

Chéng jiù means "success in whatever you do."

The first character, chéng, has a long slanting stroke to the right, balancing its left side with a slightly longer stroke. The two components of the character jiù combine straight and curved lines. To put them side by side, so that you are writing one character rather than two, make the stroke in step 15 close to the first half, so that the two sides of the character counterbalance one another.

DIRECTORY OF CHINESE CHARACTERS

21 Selfless
Wú wǒ

01–12 13–19

Wú means "without" or "nothing" and wǒ is the pronoun "I"—so together, they mean "selfless."

Note that the second character wǒ has two sides, which are linked together by the top horizontal stroke.

1	2	3	4
5	6	7	8
9	10	11	12
13	14	15	16
17	18	19	

22 Pride
Zì zūn

01–06 07–19

Zì: the rectangular form is built up in separate strokes but can be enlivened by not completely lifting the brush between strokes.

Zūn: This has a more complex structure; note how the rectangle can be enlivened if Running Script is used.

direction of stroke
current stroke
previous strokes

1	2	3	4
5	6	7	8
9	10	11	12
13	14	15	16
17	18	19	

1	2	3	4
5	6	7	8

23 Loyalty
Zhōng

The sweeping stroke in step 6 is written with the tip of the brush lifted slightly to form a curve with a flick at the end.

1	2	3	4
5	6	7	8
9	10	11	12
13	14	15	16
17	18	19	20
21	22	23	24
25			

24 Escape
Táo bì

01–09 10–25

Táo: strong verticals are curved, the right one ending in a tick.

Bì: a complex series of small strokes in two columns, underlined with its "long road."

Both characters have in common the last three strokes that end with a strong, sweeping line across the base, meaning "long road" (first seen in Fortune page 149).

25 Forgive
Shù xīn

All of the strokes up to step 6 form two compact units; underneath these you may recognize the "heart" character (last seen in Kindness, page 151) placed symmetrically.

26 Morality
Dào dé

01–12　　13–27

Dào: this character incorporates the "long road" (last seen in Escape) sweeping stroke at the base.

　Dé: the first three strokes are in a column, separate from the more complex right-hand character. The strokes from step 24 are the same as the "heart" seen in Forgive and Love.

direction of stroke
current stroke
previous strokes

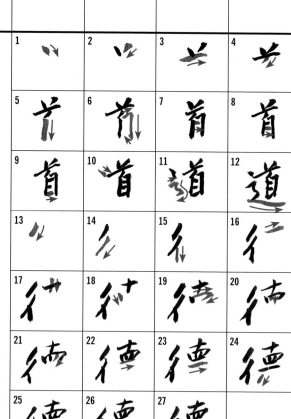

1	2	3	4
5	6	7	8
9	10	11	12

27 Dedication
Zhì lì

01–10 11–12

Zhì ("to give") consists of two columns of strokes, the first with a series of linked parallels, the second with more dynamic diagonals finishing with a strong exit stroke.

Lì ("strength"): pause at the changes of direction to make sharp corners; the final stroke should span the height of the previous characters.

1	2	3	4
5	6	7	8
9	10	11	12
13	14	15	16
17	18	19	20
21	22		

28 Explore
Tàn cè

01–11 12–22

Tàn cè means "explore." It also implies "to seek and measure."

Tàn has a "hand" on its left side to indicate movement. Any character with this component always depicts action.

Cè means "test." It has "water" on its left because it was used to describe "measure the deep." Its middle and right components (a shell and a knife) give the character its sound.
To make the character look well balanced, the middle part can be shorter than the other two.

158

DIRECTORY OF CHINESE CHARACTERS

29 Diligent
Kè kǔ

01–08 09–17

Kè ("to dig deep"): balance the widths of the parallel strokes stacked above each other, and match their height with the last vertical stroke of the "knife," which is step 8.

Kǔ: a symmetrical character with two crosses on top counterbalanced by the smaller closed form at the bottom.

30 Decision
Jué dìng

01–07 08–15

Jué: the curved vertical comes full height to stabilize the right-hand part of the character.

Dìng ("settled"): make the final diagonal strokes powerful, with the right-hand one longer than the left.

direction of stroke
current stroke
previous strokes

工作

AFFIRMATIONS

1	2	3	4
5	6	7	8
9	10	11	12
13	14	15	16
17	18	19	20
21			

31 Brave
Yŏng gǎn

01–09 10–21

The first character, yŏng, has the sound element of yŏng on top, which gives the meaning of "gushing out."

Gǎn means "strive forward" and "dare." It has two parts; both indicate "hands." The strokes in steps 17 and 21 expand outward to balance the character.

1	2	3	4
5	6	7	8
9	10		

32 Work
Gōng zuò

01–03 04–10

Gōng ("work"): two horizontal strokes spanned by a vertical, symbolizing the work of measuring.

Zuò ("to do"): make dynamic movements in these strokes, especially the final one.

DIRECTORY OF CHINESE CHARACTERS

33
Encouragement
Gŭ lì

1–13 14–30

Gŭ ("to drum" or "to beat") and lì ("to work hard") together mean "encouragement."

The many strokes in the characters convey the message of force. Deal with the strokes with the same kind of drive, making sure that the parts stay close together in a block so that they are not mistaken for more than two characters.

1	2	3	4
5	6	7	8
9	10	11	12
13	14	15	16
17	18	19	20
21	22	23	24
25	26	27	28
29	30		

direction of stroke
current stroke
previous strokes

1	2	3	4
5	6	7	8
9	10	11	12
13	14	15	16
17	18	19	20
21	22		

34 Power
Quán

This character is composed mainly of straight lines. In order to make the writing look softer, you can link the strokes in steps 21 and 22.

1	2	3	4
5	6	7	8
9	10	11	12
13	14		

35 Strength
Lì liàng

01–02 03–14

Lì ("strength") is also found in the characters for Dedication and Brave.

Liàng: balance the proportions; link the strokes for softer writing.

36 Endurance
Rěn

Balance these two dynamic forms—"knife" at the top, "heart" at the bottom—so they have equal weight.

1	2	3	4
5	6	7	

37 Respect
Zūn jìng

01–13 14–26

Zūn is a taller character than jìng, but the latter is wider. The difference in the shape of the characters often contributes to the beauty of the whole piece of writing. Maintain the symmetry and parallel lines in zūn to contrast this character with jìng.

1	2	3	4
5	6	7	48
9	10	11	12
13	14	15	16
17	18	19	20
21	22	23	24
25	26		

direction of stroke
current stroke
previous strokes

1	2	3	4
5	6	7	8
9	10	11	12

38 Wisdom
Zhì

This character is composed of three symbols: steps 1–5 form "bow and arrow"; steps 6–8 make a closed shape symbolizing "mouth" (together indicating a "mind as fast as arrows"). Centralize the lower symbol ("sun" or "express") to balance the character.

1	2	3	4
5	6	7	8
9	10	11	12
13	14	15	16
17	18	19	20
21	22	23	24

39 Discover
Fǎ xiàn

01–13 14–24

Xiàn: write these two elements close enough to read as one character, and finish with a final sweeping stroke.

40 Empower
Cù shǐ

01–09 10–17

Cù means "drive" and shǐ means "to enable," so together cù shǐ means "empower."

Cù: apply pressure to thicken the end of the last stroke.

Shǐ: apply pressure to the final diagonal to make it strong.

1	2	3	4
5	6	7	8
9	10	11	12
13	14	15	16
17			

41 Create
Chuāng zuò

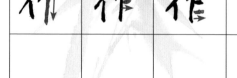

01–12 13–19

The sound element of chuāng ("to create" or "to injure") is on the left side of the character, while a knife is at its right side.

Zuò is "do"; the right side means "an immediate reaction." The character for "person" appears on the left side. Make the "person" character, then the remaining part, taking care to fuse these as one unit.

1	2	3	4
5	6	7	8
9	10	11	12
13	14	15	16
17	18	19	

direction of stroke
current stroke
previous strokes

1	2	3	4
5	6	7	8
9	10	11	12
13	14	15	16
17	18	19	20
21	22	23	24

42 Positive
Kĕn dìng de

肯定的

01–08 09–16 17–24

Kĕn means "yes." Dìng has a zhēng ("proper" or "unbiased") underneath a house and means "settled." De is used here for emphasis.

Dìng: apply pressure and release for the strong final diagonal stroke.

De: keep elements 17–24 together as one unit.

1	2	3	4
5	6	7	8
9	10	11	12
13	14		

43 Strive forward
Zhēng qǔ

争取

01–06 07–14

Zhēng means "to fight for one's desire" and qǔ is "to take." The horizontal stroke and the central vertical stroke in zhēng balance the character with their firm stances.

Qǔ has a smaller element on its right and is shielded by the upper long horizontal stroke.

44 Aim
Zōng zhí

宗 旨

01–08 09–14

Use the tip of the brush to make each stroke rounded, twisted, and, at the same time, elegant and smooth. This can be achieved by twisting the brush occasionally while writing.
In the first character, there are many changes in direction; keep all strokes balanced in weight.

1	2	3	4
5	6	7	8
9	10	11	12
13	14		

45 Intelligence
Cái zhì

才 智

01–03 04–15

Cái: this means "a new plant shooting up," implying a person with inner talents. Keep the upright stroke forceful and in proportion to the horizontal.

Zhì: this character means "wisdom." Centralize the lower symbol ("sun" or "express") to balance the character.

1	2	3	4
5	6	7	8
9	10	11	12
13	14	15	

direction of stroke
current stroke
previous strokes

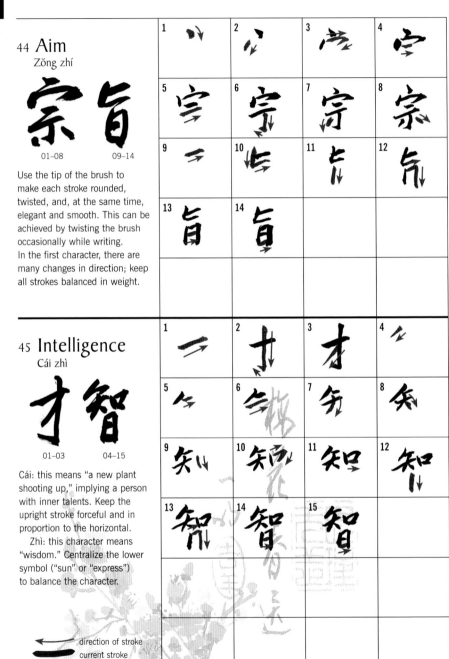

1	2	3	4
5	6	7	8
9	10	11	12
13			

46 Cooperation
Hé zuò

01–06 07–13

Hé means "join." Zuò means "operate" or "work," and together the two characters indicate "cooperation."

Zuò: take care to keep the two components of this character close together.

1	2	3	4
5	6	7	8
9	10	11	12
13	14	15	16
17	18	19	20
21	22	23	24
25			

47 Excellent
Yōu xiù

01–17 18–25

Yōu means "distinction." There is rén at its left to indicate "people's activity." The other side is yōu, which is the sound element to the character. Note that yōu ("worried") has xīn ("heart") in the middle and the bottom part means "walk." This lower element requires a strong final stroke.

Xiù has hé ("crop") on top with a nai ("hard to express") below it. Xiù means "beautiful in an intellectual sense" or "excellent." Be sensitive to the direction changes, especially lift-offs.

48 Prosper

Shùn lì

01–11 12–18

Shùn means "moving smoothly" and lì is "benefit" or "good for" or "sharp." The left component of shùn, with three downward strokes, tells you that it is a river. Keep the middle of the first three strokes shorter; write the more complex sequence with rhythmic, even strokes.

Lì has a hé ("crop") at its left and a knife at its right, indicating a harvest. The vertical stroke in step 14 stabilizes the form, so make sure it is strong.

1	2	3	4
5	6	7	8
9	10	11	12
13	14	15	16
17	18		

49 Prosper (colloquial)

Fā

Balance the weights of all these small elements by using a delicate touch with the brush, but be generous with the top sweeps.

1	2	3	4
5	6	7	8
9	10	11	12
13			

direction of stroke
current stroke
previous strokes

1	**2**	**3**	**4**
5	**6**	**7**	**8**
9	**10**	**11**	**12**
13	**14**	**15**	**16**
17	**18**	**19**	**20**
21	**22**		

50 Happiness
Kuài lè

快 樂

01–07 08–22

Kuài lè means "happy." Kuài in itself means "fast" and lè is "music" or "happy."

Kuai has a "heart" (xīn) on its left, and the element at its right means "a hand" and "separate."

Lè is heavy on top, so the horizontal stroke in the middle is an important element to balance the character.

1	**2**	**3**	**4**
5	**6**	**7**	**8**
9	**10**	**11**	**12**
13	**14**	**15**	**16**
17	**18**		

51 Win
Yíng

贏

The character yíng has many strokes and is quite a complicated construction.

Yíng has five elements. Regulate the space to allow room for all of them.

DIRECTORY OF CHINESE CHARACTERS

52 Assertiveness
Jiān chí

01–12 13–21

Jiān: the bottom element must be strong enough to balance the two upper ones.

Chí: there is a vertical stress to these elements. Pause before changing direction for the base flicks.

1	2	3	4
5	6	7	8
9	10	11	12
13	14	15	16
17	18	19	20
21			

53 Determination
Jué xīn

01–07 08–11

Jué means "determined" or "separate." The short stroke in step 7 should be firm to stabilize the whole character.

Xīn means "heart." Note, the top two dots (steps 10 and 11) should be written differently facing different directions.

1	2	3	4
5	6	7	8
9	10	11	

direction of stroke
current stroke
previous strokes

1	2	3	4
5	6	7	8
9	10	11	12
13	14	15	16
17	18	19	20

54 Goal
Mù biāo

01–05　　06–20

Mù, meaning "eye," developed from the pictographic image of a child's face, with eyebrow and eye.

Biāo has a mù ("wood") on its left side to indicate wooden signage. Keep the vertical stroke in step 7 very long, and use the brush's point to accommodate all the detail in the right-hand element.

1	2	3	4
5	6	7	8
9	10	11	12
13	14	15	16
17	18	19	20

55 Reach
Dào dá

01–08　　09–20

Dào is composed of two parts: the left component means "reach," with a bird arriving on the ground. The right-hand side is "knife." Keep the strokes lively.

Dá means "arrived." Don't stop between strokes, or you will lose the qì of the character. Keep strokes compact to allow space for "the long road," which runs in a wide sweep underneath.

56 Trustworthy
Kě kào

01–05 06–20

Kě means "yes" or "positive" and kào means "reliable."

From step 14 onward, the three short strokes on both vertical strokes can be written in a slightly irregular fashion to give some light relief to the character.

1	2	3	4
5	6	7	8
9	10	11	12
13	14	15	16
17	18	19	20

57 Hero
Yīng xióng

01–10 11–22

Yīng: spread the last strokes (steps 9 and 10) under the horizontal to balance the top.

Xióng: this consists of two elements that must be close to each other to resemble the one character.

1	2	3	4
5	6	7	8
9	10	11	12
13	14	15	16
17	18	19	20
21	22		

direction of stroke
current stroke
previous strokes

1	2	3	4
5	6	7	8
9	10	11	12
13	14	15	16
17	18	19	

58 Recognize
Rèn kě

01–14 15–19

Rèn: The top-right part means "knife" and xīn ("heart") is underneath it. Putting a knife against your heart is "endurance." The left side means "to speak."

Kě means "yes" or "can do." Keep the two elements close as one character while making the strokes lively, pausing at the corner of the last stroke for a flick.

1	2	3	4
5	6	7	8
9	10	11	12
13	14	15	16
17	18	19	20
21			

59 Recommend
Tuī jiàn

01–11 12–21

Look at the above example of these two characters. In steps 5 and 18, after you have written the vertical strokes, you can apply "linking threads" in between to carry the qì from one stroke to the next.

60 Great men
Wěi rén

01–12 13–14

Wěi: the first two strokes are "person"; keep all of the small strokes on the right-hand side lively but confined within the vertical space.

Rén ("people"): make the two sweeping strokes, resembling striding legs, with extra pressure on the right stroke, tapering to a point.

1	2	3	4
5	6	7	8
9	10	11	12
13	14		

61 Greatness
Wěi dài

01–12 13–15

Dài ("big") has only three strokes; the horizontal stroke balances the whole character. The stroke sweeping to the left is usually shorter than the stroke on the right (see steps 14 and 15).

1	2	3	4
5	6	7	8
9	10	11	12
13	14	15	

direction of stroke
current stroke
previous strokes

1	2	3	4
5	6	7	8
9	10	11	12
13	14	15	16
17	18	19	20
21	22	23	24
25	26	27	28
29	30	31	32
33	34		

62 Kindness, righteousness, loyalty, and trust

Rén, yì, zhōng, xīn

01–04 05–17 18–25 26–34

Rén ("kindness"), yì ("righteousness"), zhōng ("loyalty"), and xīn ("trust") are the four virtues traditionally needed for a man to become a gentleman.

The first character, rén, depicts two people, which denotes that kindness exists between people.

The character me, on the lower half of yì, connotes that the virtue of righteousness starts from oneself.

"Loyalty" in Chinese is zhong: "central" is on top of "heart" (xīn), indicating that an unbiased heart is required to be a faithful and loyal person.

Xīn means "trust" where "word" is next to "people," telling us that people should speak the truth.

Love

The brush is a vehicle for your expression. Through its responsiveness, you will come to understand your inner self. Be prepared to surprise yourself—just pick up the brush, follow the simple instructions, and see what happens.

1 Companion

Tóng bàn

01–06　　　07–13

Tóng: the central strokes are practically embraced by the outer strokes.

Bàn: balance the lengths of the horizontals against the sturdy upright.

1	2	3	4
5	6	7	8
9	10	11	12
13			

2 Desire

Yāo qiú

01–09　　　10–16

Yāo means "want." The long stroke across the bottom counterbalances the character.

Qiú means "acquire" or "beg." It has four slanting strokes that point inward toward the center; the dot on the top right corner balances the whole character.

1	2	3	4
5	6	7	8
9	10	11	12
13	14	15	16

direction of stroke
current stroke
previous strokes

1	2	3	4
5	6	7	8
9	10	11	12
13	14	15	16
17	18	19	

3 Delight
Yú kuài

愉 快

01–12 13–19

There are several ways to express "delight," depending on the context. Here, it is expressed as yú kuài. Yú means "happiness." Its left component is xin ("heart"), indicating emotion. You may have noticed that xin is written differently when it is used at the left side of a character. The strokes have been stretched and lengthened.

1	2	3	4
5	6	7	8
9	10	11	12
13	14	15	16
17	18	19	20

4 Precious
Zhen gui

珍 貴

01–09 10–20

Zhen means "precious." It has "jade" on its left to express the quality of this character. The sound of Zhen is given by its right side, where the slanting strokes represent a woman's hair, luscious and dark. The last stroke should be the longest in order to balance the character.

Gui means "expensive and precious." The top of gui is a zhong ("center and within") with a horizontal stroke across and followed by the character bei ("shell"), which was used as a form of currency in the past.

5 Beauty
Měi

The separate stroke in the bottom half of the character should be the longest, with the two slanting strokes across it and to its right, counterbalancing the character.

1	2	3	4
5	6	7	8
9			

6 Passion
Rè qíng

01–15 16–26

The first character, rè, means "hot," while qíng means "love." Together, they mean "passion." The presence of heat is indicated by four dots ("fire"). If you refer to the section on Meditations (page 212), you will find the character for "fire" (huǒ), which is derived from a pictogram.

Qíng (pronounced tsing) expresses emotion; this is indicated by the symbol xīn ("heart") on the left side.

1	2	3	4
5	6	7	8
9	10	11	12
13	14	15	16
17	18	19	20
21	22	23	24
25	26		

direction of stroke
current stroke
previous strokes

1	2	3	4

7 Heart
Xīn

With a sweeping stroke bending to the right, xīn resembles a boat. The position of the curved line is important, as the balance of the character will depend on it. Use the tip of your brush to continue the stroke, ending with two short strokes (dots) on top.

1	2	3	4
5	6	7	8
9	10	11	12
13	14	15	16
17	18	19	20
21	22	23	24
25	26		
27	28	29	30
31	32		

8 Compassion
Tǐ xù

01–23 24–32

Tǐ: Use a light touch to retain the detail in these many strokes, and pay attention to relative stroke lengths.

Xù: balance these fewer strokes against the weight of the first character.

9 Gentle
Wēn yǎ

01–04 05–16

Wēn indicates fine arts, but cannot be used on its own. When linked with another character, the meaning becomes obvious. It has only four strokes. The last two sweeping strokes balance the whole character.

Yǎ means "elegant and gentle." Yǎ, the sound element, is situated at the left side of the character. The right-hand side means a short-tailed bird.

1	2	3	4
5	6	7	8
9	10	11	12
13	14	15	16

10 Bliss
Zhì lè

01–06 07–21

Zhì means "extreme" and lè means "happiness." Zhì is made up of only six strokes, but four are horizontal. When spacing these strokes, leave even spaces between them so they don't look squashed. The many strokes on the top half of lè weigh down on the long horizontal stroke running through the center of the character.

1	2	3	4
5	6	7	8
9	10	11	12
13	14	15	16
17	18	19	20
21			

direction of stroke
current stroke
previous strokes

1	2	3	4
5	6	7	8
9	10	11	12
13	14	15	

11 Trust
Xīn rèn

信任

01–09　　　　10–15

Xin means "trust." Ren means "good" and "kind." The character has two parts; ren, meaning person, is on the left. The right side means "perfect" or "right." This character has two horizontal strokes. The top stroke should be longer than the bottom one.

1	2	3	4
5	6	7	8
9	10	11	12
13	14	15	16
17	18	19	

12 Warmth
Qīn qiē

親切

01–15　　　　16–19

Each character has two parts, so be sure to write these close to one another to prevent them from looking as if they are four separate characters.

Although the two sides of qīn seem to face squarely forward, the strokes of the second character, qiē, bend slightly inward, making them appear more intimate.

The horizontal stroke at the beginning of qiē is written with a flick upward, to create a continuation of movement to the next stroke.

DIRECTORY OF CHINESE CHARACTERS 摧花

13 Gratitude
Xie Yi

01–17 18–30

Xie: this character is quite complex until you break down the components; keep them all to the same height.

Yi: the second horizontal is wide and the "heart" at the bottom balances that width.

1	**2**	**3**	**4**
5	**6**	**7**	**8**
9	**10**	**11**	**12**
13	**14**	**15**	**16**
17	**18**	**19**	**20**
21	**22**	**23**	**24**
25	**26**	**27**	**28**
29	**30**		

direction of stroke
current stroke
previous strokes

1	2	3	4
5	6	7	8
9	10	11	12
13	14	15	

14 Caring
Xì xīn

01–11 12–15

Xì xīn is one of several ways of saying "caring." Xì means "small," while xīn is "heart." "Small heart" is used to describe a caring person.

Xì has "silk" at its left, which has the meaning of "fine and delicate." On its right is tian; although it means "field," in the past, it was written and interpreted as "brain."

1	2	3	4
5	6	7	8
9	10	11	12
13	14	15	16
17	18	18	20
21	22	23	

15 Embrace
Yōng Bào

01–15 16–23

These are characters of action as indicated by the hand on the left. Delicate strokes in steps 5 to 15 balance with the hand on the left.

16 Together
Yī qǐ

一起

01 02–11

Qǐ: the right diagonal at the bottom spreads wider than the left diagonal, to sweep underneath the right-hand element for balance.

1	2	3	4
5	6	7	8
9	10	11	

17 Cherish
Zhēn xī

珍惜

1–09 10–20

Zhēn means "precious."
A slight change in the direction of the third slanting stroke in zhēn (step 9) balances and enhances the beauty of the whole character.

Xī is "to treasure." While the xī on the right gives the sound of the character, the "heart" on the left indicates emotion.

1	2	3	4
5	6	7	8
9	10	11	12
13	14	15	16
17	18	19	20

direction of stroke
current stroke
previous strokes

一起 LOVE

1	2	3	4

18 Ecstasy
Rù mí

入迷

01–02 03–12

Mí: the vertical line holds the shape, as the dots radiate out; note the "long road" bottom element with its extended base stroke.

5	6	7	8

9	10	11	12

1	2	3	4

19 Tender
Wēn róu

温柔

01–12 13–21

Róu: keep the middle horizontal wide, and the final strokes radiating out in balance.

5	6	7	8

9	10	11	12

13	14	15	16

17	18	19	20

21			

20 Radiant
Míng yàn

1–08 09–36

Yàn: these are complex structures to be built with light strokes so as to accommodate them in the space. The left side's top-heavy character is neatly counterbalanced by the bottom-heavy right-hand part.

direction of stroke
current stroke
previous strokes

1	2	3	4
5	6	7	8
9	10	11	12
13	14	15	16
17			

21 Sympathy
Tóng qíng

同情

01–04 05–19

Tóng: the central strokes are embraced by the outer strokes. Qing includes "heart" and is a also seen in Valentine's Day on page 134 and 178, Passion.

1	2	3	4
5	6	7	8
9	10	11	12
13	14	15	16
17	18	19	

22 Friendship
Yǒu yì

友誼

01–04 05–19

The first character, yǒu, means "friend," while yì indicates "relationship."

The example above shows some links between the strokes; this is known as Xin Shu ("Running script") style. Make sure that these are just links, not strokes, so that they appear as "threads."

23 Pretty
Piào liang

漂亮

01–14 15–22

The first character, piào, means "float"—it has shui ("water") at its left. Note, however, that when shui is used at the left side of a character, as here, it is reduced to three short strokes.

Liang means "bright." There are two sweeping strokes under the cover at the lower half of the character, to express the fact that the higher the ground, the brighter it is.

24 Union
Jié hé

結合

01–12 13–18

The top inward-sloping strokes of hé and the horizontal stroke beneath them mean "heaven," "people," and "earth." At step 14, press the brush down and continue the stroke to the right to form a "duck's tail."

⟵ direction of stroke
━ current stroke
━ previous strokes

1	2	3	4
5	6	7	8
9	10	11	12
13	14	15	16
17	18	19	20
21	22	23	24
25	26	27	28
29			

25 Grace
Yōu yǎ

優雅

01–17 18–29

Yōu: the right-hand element of this character is a complex construction—balance it with the two strong strokes of its companion.

Yǎ: the two halves of this character are meshed gently together with the central uprights and diagonals.

LOVE

Meditations

Practicing brushwork can give you a sense of strength and connection with your inner self. Many Chinese calligraphers are also practitioners of T'ai Chi Chuan and Qi Gung, both of which share a similar, meditative ethos.

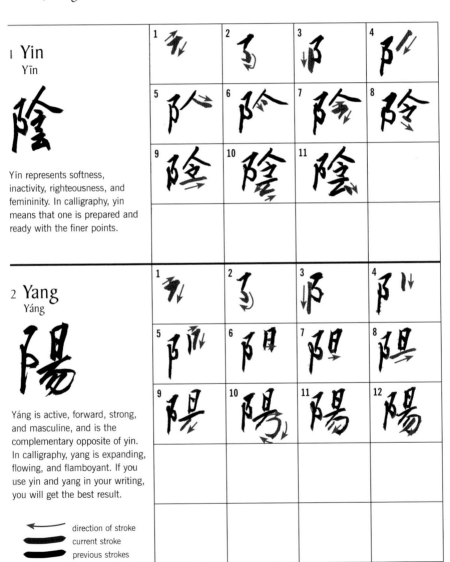

1 Yin
Yīn

Yīn represents softness, inactivity, righteousness, and femininity. In calligraphy, yin means that one is prepared and ready with the finer points.

2 Yang
Yáng

Yáng is active, forward, strong, and masculine, and is the complementary opposite of yin. In calligraphy, yang is expanding, flowing, and flamboyant. If you use yin and yang in your writing, you will get the best result.

direction of stroke
current stroke
previous strokes

1	2	3	4
5	6	7	8
9	10	11	12
13	14	15	16
17	18	19	20
21	22	23	24
25	26	27	28
29	30	31	32
33	34	35	36
37	38		

3 Soul

Líng hún

1–24 25–38

Hun: keep the two elements of the character close together, to make a unit; be generous with the stroke in step 36 to accommodate the final element.

4 Thought

Sī OR Xīn

1	2	3	4
5	6	7	8
9			

In the second stroke of the xīn "heart," step 7, start with the point of the brush and pay attention to the two dots on top formed in different directions.

5 Meditation

Míng xiǎng

01–10 11–23

Xiǎng: balance the "heart" centrally to the upper two elements, and use the point of the brush to obtain a sharp beginning to this shape.

1	2	3	4
5	6	7	8
9	10	11	12
13	14	15	16
17	18	19	20
21	22	23	

← direction of stroke
current stroke
previous strokes

1	2	3	4

6 T'ai chi
Tài jí

1–04 05–17

Tài: in step 3 apply pressure and release to make a strong then tapered stroke.

Jí: keep the two units close together, and make the final horizontal wide enough visually to support the upper structure.

5	6	7	8
9	10	11	12
13	14	15	16
17			

1	2	3	4

7 Taoism
Dào

Taoism is one of the schools of philosophy originating from the Han dynasty. Dào (Taoism) is the way that Lao-tzu indicated we should follow. He taught that it is wise not to be materialistic and that this is the right way to achieve a happy, wholesome life.

5	6	7	8
9	10	11	12
13			

8 No Limit
Wú jí

01–12 13–25

According to Yi Jing, *The Book of Change*, wú jí existed before t'ai chi. Wu means "nothing" and jí means "limit" (see t'ai chi, page 193).

Each of the four dots at the bottom of wú should be written slightly differently to convey movement. This applies to all the other strokes, which should show a continuation of spirit from beginning to end.

9 Nothingness
Kòng

The final stroke can be written longer if necessary to support the whole character.

direction of stroke
current stroke
previous strokes

1	2	3	4

10 Realization
Wù

悟

It is wonderful when we achieve wù ("realization"). The left side of wù shows a xīn ("heart") to indicate the involvement of our inner self.

5	6	7	8

9	10		

1	2	3	4

11 Harmony
Hé xié

和諧

01–08 09–24

Here, hé means "mix" and xié means "harmonious."

You can see a "flick" in step 3, which may seem to be essential in this character, but the flick can be omitted if you wish. If you are following the classic form (Kai Shu), insert the flick.

5	6	7	8

9	10	11	12

13	14	15	16

17	18	19	20

21	22	23	24

12 Carefree
Zì zài

自在

01–06　　　07–12

Zài: note that stroke 8 has a curve, and the horizontal is wide, allowing space for the final element to sit underneath.

1	2	3	4
5	6	7	8
9	10	11	12

13 Spirit
Jìng shén

精神

01–14　　　15–23

When you execute the strokes in jìng shén or any other character, the spirit that you impart is important. Let the strokes talk, salute, and greet each other. Characters without any flow of qì are considered not to be alive.

1	2	3	4
5	6	7	8
9	10	11	12
13	14	15	16
17	18	19	20
21	22	23	

direction of stroke
current stroke
previous strokes

1	**2**	**3**	**4**
5	**6**	**7**	**8**
9	**10**	**11**	**12**
13			

14 Fulfillment
Wán chéng

01–07 08–13

Wán chéng means "fulfillment," in which wán means complete" and chéng means "done."

In step 11, the slanting stroke to the right ends with a "flick," but in the example above, this was not inserted. This is because in calligraphy, a flick can sometimes be omitted. However, for the classic form, a flick should be added.

1	**2**	**3**	**4**
5	**6**	**7**	**8**
9	**10**	**11**	**12**
13	**14**	**15**	**16**
17	**18**	**19**	**20**
21	**22**		

15 Journey
Lǚ chéng

01–10 11–22

Follow the individual strokes to discover the structure, then develop rhythm by writing more fluidly to obtain richer writing. Running script, for example, is used in steps 21 and 22, where the last two horizontals show a joining stroke.

16 Acceptance
Jiē shòu

01–11 12–19

Jiē: ensure that the vertical stroke is long enough to balance the second, more complex element.

Shòu: give emphasis to the final stroke to the right, adding pressure to thicken, then taper.

1	2	3	4
5	6	7	8
9	10	11	12
13	14	15	16
17	18	19	

17 Belief
Xīn niàn

01–09 10–17

Xìn: when written at speed, some of the individual strokes will show thin joining lines.

Niàn: with the "heart," make the curved shape by starting with the point of the brush for a sharp beginning to the stroke.

1	2	3	4
5	6	7	8
9	10	11	12
13	14	15	16
17			

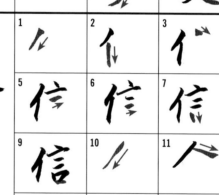

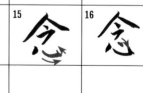

direction of stroke
current stroke
previous strokes

1	2	3	4
5	6	7	8
9	10	11	12

18 Mystery
Xuán miào

01–05 06–12

Xuán: develop rhythm in the zigzag strokes 3–5.

 Miao: make the final diagonal stroke strong and long to complete the character.

1	2	3	4
5	6	7	8
9	10	11	12
13	14	15	16
17	18	19	20
21			

19 Miracle
Qǐ Jí

01–08 09–21

Qǐ: keep the second horizontal wide to support the element above, and make the vertical a similar depth.

 Jí: keep the two halves close together, and balance the proportions.

20 Imagine
Xiǎng xiàng

01–13 14–27

Both of these characters are pronounced "xiǎng." The first xiǎng has three elements to balance together, with the "heart" at the base filling the width.

In the right-hand part of the second xiàng, keep strokes short to fit them all into the small space.

1	2	3	4
5	6	7	8
9	10	11	12
13	14	15	16
17	18	19	20
21	22	23	24
25	26	27	

21 Insight
Wù lì

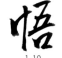

1–10 11–12

It can take a considerable effort to construct simple characters. The second character, lì, has only two strokes, but you will have to think ahead in order to achieve a balanced character.

direction of stroke
current stroke
previous strokes

1	2	3	4
5	6	7	8
9	10	11	12

1	2	3	4
5	6	7	8
9	10	11	12
13	14	15	16
17	18	19	20
21	22	23	24
25	26	27	28
29	30	31	32
33	34	35	36

22 Inspiration
Líng gǎng

1–23　　　　24–36

Líng: the second horizontal is the widest, and is domed. The complexity of structures beneath this requires a delicate touch with the tip of the brush.

Gǎng: ensure that the diagonal (step 34) is strong enough to balance the elements to its left.

MEDITATIONS

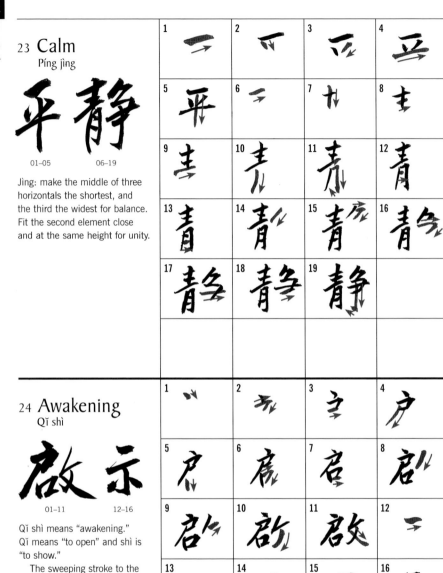

23 Calm
Píng jìng

01–05 06–19

Jìng: make the middle of three horizontals the shortest, and the third the widest for balance. Fit the second element close and at the same height for unity.

24 Awakening
Qǐ shì

01–11 12–16

Qǐ shì means "awakening." Qǐ means "to open" and shì is "to show."

The sweeping stroke to the right in step 11 is essential to create a well-balanced character.

direction of stroke
current stroke
previous strokes

1	2	3	4
5	6	7	8
9	10	11	12

25 Angel
Tiăn shĭ

01–04 05–12

Tiăn: press hard for dramatic sweep to stroke 4.

Shĭ: repeat the drama with a similarly powerful final diagonal stroke.

1	2	3	4
5	6	7	8
9	10	11	12
13	14	15	16
17	18	19	20
21	22		

26 Divine
Shén shèng

01–09 10–22

"Shén shèng" means "divine." The first character, shén, is "God" and the second one means "saint."

Whenever there is a turn with a stroke going in the opposite direction, you can always start a new stroke at the place where the last one ends, as in steps 6 and 17.

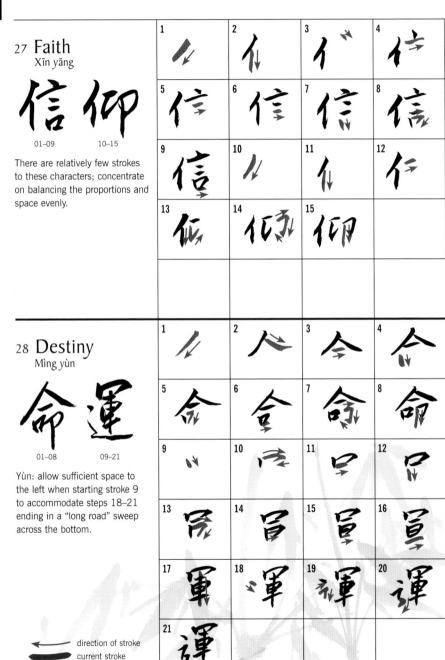

27 Faith
Xīn yǎng

信 仰
01–09 10–15

There are relatively few strokes to these characters; concentrate on balancing the proportions and space evenly.

28 Destiny
Mìng yùn

命 運
01–08 09–21

Yùn: allow sufficient space to the left when starting stroke 9 to accommodate steps 18–21 ending in a "long road" sweep across the bottom.

← direction of stroke
current stroke
previous strokes

1	2	3	4
5	6	7	8
9	10	11	12
13	14	15	16
17	18	19	20
21			

29 Relax
Fàng kūan

01–08 09–21

Fàng: balance the proportions and give strength to the final diagonal stroke.

Kūan: here, a lot of small strokes are in a confined space; sweep the final curve around and pause before the "flick" at the end, and do not forget the dot.

1	2	3	4
5	6	7	8
9	10	11	12
13	14	15	16
17	18		

30 Vision
Huàn xiàng

1–04 05–18

Huàn: balance the placing of the few strokes in this character with the complexity in xiàng.

Xiàng: make small delicate strokes to fit in all the detail and finish with a strong diagonal sweep.

31 Truth
Zhēn xiàng

真 相
01–10 11–19

Zhēn: the bottom horizontal is wider than the top one, for balance.

Xiàng; retain the proportions of the rectangle to balance that of zhēn.

1	2	3	4
5	6	7	8
9	10	11	12
13	14	15	16
17	18	19	

32 Dream
Mèng

夢

Once a stroke has been executed, you cannot go back and correct it, so think carefully before writing and do not be deterred by repeated errors. One day, your mèng (dream) of becoming a proficient calligrapher will come true!

1	2	3	4
5	6	7	8
9	10	11	12
13			

direction of stroke
current stroke
previous strokes

1	2	3	4
5	6	7	8
9	10	11	12
13			

33 Sorrow
Xīn chóu

There is a xīn ("heart") at the bottom of chóu, which means "sorrow."

Write "heart" large enough to support the heaviness of the top part of the character. Remember that momentum should be carried through the character.

1	2	3	4
5	6	7	8
9	10	11	12
13	14	15	16
17	18	19	20
21	22		

34 Memories
Huí yì

01–06 07–22

Yì: keep the second horizontal wider than the top; start the second stroke of "heart" with the point of the brush for definition.

35 Eternity
Yŏng héng

永恆

01–05 06–13

Héng: leave enough space in the zigzags 11–12 to accommodate the final dot.

36 Balance
Píng héng

平衡

01–05 06–21

Each character has its own way of balancing ("píng héng"). Whether it is in the handling of the brush or the spacing and structure of the strokes, the skill of the calligrapher is all-important. A dot positioned slightly out of place can spoil a well-written character. Therefore, careful thought should be given to its construction beforehand.

direction of stroke
current stroke
previous strokes

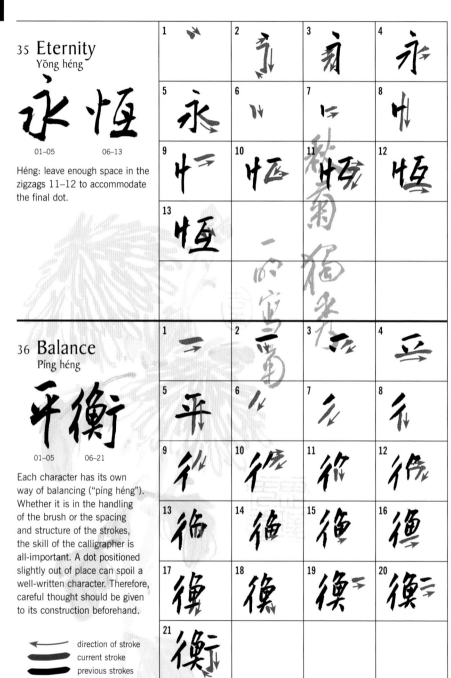

1	**2**	**3**	**4**
5	**6**	**7**	**8**
9	**10**	**11**	**12**
13			

37 Patience
Nài xīn

01–09 10–13

Xīn ("heart") has only four strokes, which can easily convey the elegance of the character when they are placed correctly. Of course, the movement that comes from your brush technique, which gives the character its spirit, is the backbone of the art of calligraphy.

1	**2**	**3**	**4**
5	**6**	**7**	**8**
9	**10**	**11**	**12**
13	**14**	**15**	**16**
17	**18**	**19**	**20**
21	**22**	**23**	

38 Surrender
Shě qì

01–11 12–23

Shě: keep strokes 4–5 wide enough to cover the small strokes beneath.

Qì: the middle horizontal is the widest, balancing the form, while the strong vertical provides stability.

39 Wish
Dàn yuàn

但願

With practice, you will write more quickly and fluidly, so some strokes will merge together (especially when making the rectangles) to allow a continual flow of energy.

1	2	3	4
5	6	7	8
9	10	11	12
13	14	15	16
17	18	19	20
21	22	23	24

40 Tranquility
Jìng

In the left-hand part of the character, the third horizontal completing the upper element separates the two forms.

The right-hand character has a strong vertical which gives stability.

1	2	3	4
5	6	7	8
9	10	11	12
13	14		

direction of stroke
current stroke
previous strokes

1	2	3	4

41 Metal
Jīn

According to Chinese philosophy, the five elements in the universe are metal, wood, water, fire, and earth. Metal (jīn) is the first element.

1	2	3	4

42 Wood
Mù

You will find that this character (mù) often appears as a part of other characters. Its appearance usually refers to the meaning of "wood."

Execute the strokes with vigor to achieve the qi of the character.

43 Water
Shuǐ

For the vertical stroke, pay attention to brush technique, press, and lighten pressure down, pause, then flick. Give the diagonal a strong "kick" outward.

1	2	3	4
5			

44 Fire
Huǒ

Huǒ is often used as four dots at the bottom of a character when it has the meaning of "fire." Huǒ is a beautiful character with two dots on top and two long, sweeping strokes spreading out on both sides. Balance them well and it will produce a fiery character.

1	2	3	4

direction of stroke
current stroke
previous strokes

水

1	2	3	

45 Earth
Tǔ

Tǔ is the last of the five elements. There are only three strokes in this character. Make them appear to be strong, stable, and earthy. The bottom stroke is longer than the top one.

1	2	3	4
5	6	7	8
9	10		

46 Five elements
Wǔ xíng

01–04 05–10

Sometimes, as shown in the example character above, a "linking thread" appears between the strokes, and that is when the energy of qì occurs between one stroke and the next. The tip of the brush touches the paper very lightly to create a thread before another stroke starts.

Prayers

Chinese calligraphy is not just the writing of characters, it extends further, into the body and mind. The movements of your hand, arm, and body as you make the brushstrokes are guided by your inner voice, creating harmonious lines.

1 Buddha
Fó

佛

1	2	3	4
5	6	7	8

The two vertical strokes (steps 7 and 8) slice through the horizontal lines. Try to make the right stroke longer than the left one, so that the character looks well balanced.

2 Zen
Chán

禪

In the right-hand character, the vertical stroke is powerful in stabilizing the overall form.

1	2	3	4
5	6	7	8
9	10	11	12
13	14	15	16

⟵ direction of stroke
━ current stroke
━ previous strokes

1	2	3	4
5	6	7	8
9	10	11	12
13	14		

3 Serenity
Níng

The cover on top of níng indicates a "house," followed by a "heart" (xīn) to depict the involvement of feelings, then a min ("food container") to express a feeling of comfort and security.

The horizontal stroke in step 13 resembles a long arm, stretching out to balance the whole character.

1	2	3	4
5	6	7	8
9	10	11	12
13	14	15	16
17	18	19	20
21	22		

4 Bless
Zhù fú

01–09 10–22

The two characters have the same meaning expressed through their left side, indicating something to do with ceremony.

The flick in step 9 should be added at the end of the curved stroke.

In step 20, the vertical stroke should be written first, before the horizontal one. This is to enable you to link the two horizontal strokes in steps 21 and 22, as if you are writing in Xin Shu (Running Script) style.

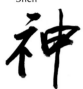

5 God
Shén

Balance these two components so that the diagonal in the first is counterbalanced by the vertical in the second.

1	2	3	4
5	6	7	8
9			

6 Prayer
Qí dǎo

01–08 09–26

The left side of both characters is the same to express the meaning of "formality" or "religious ceremony."

As there are so many strokes in dǎo, you must take care not to make the right side of the character too big.

1	2	3	4
5	6	7	8
9	10	11	12
13	14	15	16
17	18	19	20
21	22	23	24
25	26		

direction of stroke
current stroke
previous strokes

1	2	3	4
5	6	7	8
9	10	11	12
13	14	15	

7 Heaven
Tiān táng

01–04 05–15

Táng: the top horizontal, a domed shape, is the widest part, sheltering the elements below.

1	2	3	4
5	6	7	8
9	10	11	12
13	14	15	16
17	18		

8 Wish
Xī wàng

01–07 08–18

Xī means "wish" and has a vertical stroke to balance the central gravity of the character. You may have to write it many times to adjust its position.

Wàng means "look" and has one part on top of another. The top two elements share the space equally, and the bottom part, with its three horizontal strokes, stabilizes the character.

Blessings

These ideograms are popular for any celebration—you can write them on greeting cards, scrolls, or hanging decorations. Practice them by following the instructions over and over till you have mastered the characters.

1 Blessings
Fú

This character may look familiar to you, because Chinese people like to have it written in calligraphy for the New Year celebration.

1	2	3	4
5	6	7	8
9	10	11	12
13			

2 Stability
Wěn

The character wěn has more complex components on its right side than on the left. The left side of wěn has the meaning of "corn" and the other side consists of claws, labor, and heart. They indicate that stability can be obtained with hard work.

direction of stroke
current stroke
previous strokes

1	2	3	4
5	6	7	8
9	10	11	12
13	14	15	16
17	18	19	

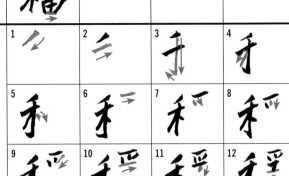

1	2	3	4
5	6	7	8
9	10	11	12
13	14	15	16
17	18	19	20
21	22		

3 Joy
Xǐ yuè

01–12 13–22

Xǐ means "happy." This character has two "kou" (mouths) and they seem to smile at you. When two xǐ are side by side, it means "double happiness." Xǐ here is a slender character with one horizontal stroke to balance it. Yuè means "pleasing and delightful." It has the sign of a heart (xin) on its left, indicating feelings. The right side of the character means "exchange".

1	2	3	4
5	6	7	8
9	10	11	12
13			

4 Peace
Hé píng

01–08 09–13

Hé means "harmony" and píng means "flat" or "calm." Together, they mean "peace." The kou (mouth) on the right side of hé is best placed next to the short stroke in step 5. Píng has two horizontal strokes; the bottom one is longer to balance the character.

5 Prosperity
Shùn lì

01–11 12–18

There are several ways to describe "prosperity" in Chinese. Shùn lì is shown here; it means "smooth-running and profitable."

Of the three vertical strokes, the middle one is the shortest to give it some space.

Lì means "profit" and "sharp." Its right side is written with a deliberate downward stroke to balance the character.

1	2	3	4
5	6	7	8
9	10	11	12
13	14	15	16
17	18		

6 Wealth
Cái fù

01–09 10–21

Cái: keep a strong, tall, vertical stroke in step 8, with a flick to stabilize it.

Fù: the "roof" balances the width of the lower enclosed shape.

1	2	3	4
5	6	7	8
9	10	11	12
13	14	15	16
17	18	19	20
21			

direction of stroke
current stroke
previous strokes

1	2	3	4

7 Expansion
Kuò dà

01–05 06–09

The character kuò has two parts. Its left side is a "hand," meaning "action," and takes up less space than the right. The right side, which has some busy components, therefore has space to expand.

Dà has two strokes, one sweeping out to each side. To make it less regular, the right side can be written more heavily than the left.

5	6	7	8
9	10	11	12
13	14	15	16
17	18	19	20

1	2	3	4

8 Forever
Yǒng

The character yǒng has eight strokes. Traditionally, these are used to introduce the eight basic strokes of Chinese calligraphy (see page 28).

5	6	7	

9 Success
Chéng gōng

01–06 07–11

Chéng is used to mean "achievement." The long slanting stroke in step 4 is important to balance the character.

Gōng: the left side means "labor" and gives the pronunciation of the character, while the right side means "strength." Therefore, effort will be needed to pursue success.

1	2	3	4
5	6	7	8
9	10	11	

10 Luck
Jí xiáng

01–06 07–16

The first horizontal stroke in the top part of jí should be longer than the second horizontal stroke, as shown in steps 1 through 3.

The second character, xiáng, has two parts: the left side indicates ceremonial matters and the right side a goat, which, in the past, was used to signify good fortune. Again, the middle horizontal stroke should be the shortest.

1	2	3	4
5	6	7	8
9	10	11	12
13	14	15	16

 direction of stroke
current stroke
previous strokes

11 Safe
Píng ān

01–05 06–11

The character "ān" means "comfort"—"nu" is resting comfortably under a roof. Extend its horizontal stroke out to balance the whole character.

1	2	3	4
5	6	7	8
9	10	11	

12 Longevity
Cháng shòu

01–08 09–22

Cháng means "long." It has four horizontal strokes, with the fourth one extended to balance the character.

Shòu has three components separated by two long horizontal strokes and supported by a vertical stroke. The strokes seem to pile on top of each other, but with even spacing between them. The character looks complicated, but it is manageable if you follow the step-by-step guide.

1	2	3	4
5	6	7	8
9	10	11	12
13	14	15	16
17	18	19	20
21	22		

Chinese flower painting

To add a modern touch to your calligraphy pieces, you may wish to incorporate some Chinese flowers, painted in a traditional style. Over the next few pages, you will learn how to paint the plum blossom, orchid, chrysanthemum, and bamboo, collectively known as "The Four Gentlemen." Colored ink sticks are available from Chinese calligraphy stores, and are prepared in same way as black ink (see pages 20–21).

Remember that a good calligrapher is a good painter. The brush techniques that you have learned for Chinese calligraphy will stand you in good stead for Chinese painting.

Plum blossom

The plum blossom is the national emblem of China. It represents the spring and symbolizes the beginning of a new year.

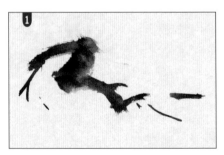

STEP 1

Load a hard brush (made of horse hair or wolf hair) with dark green and black paint. Execute the strokes vigorously, using calligraphy techniques to construct thick and twisted branches. Leave gaps in the branches for blossoms.

STEP 2

With a soft brush, fill the branches on front and back with lovely pink buds and blossoms.

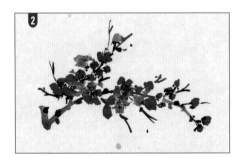

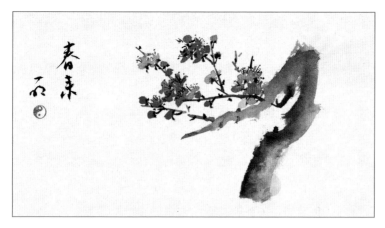

PLUM BLOSSOM VARIATION

Simply by varying the color of the flowers and the overall direction of the piece, you can achieve a different look. Think carefully about the composition of your painting; it should enhance and complement your calligraphy, not detract from it.

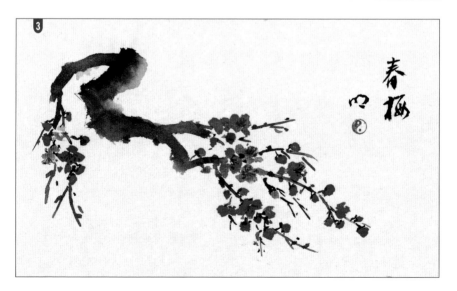

STEP 3

Add the calyxes and stamens with dark or black paint. With a soft brush loaded with pink paint, make lots of circles on and along the branches. When it is finished, inscribe your name in a suitable place and stamp your seal underneath.

Orchid

Orchids are delicate plants that grow on the hillside. Their flowers are gentle and shy; their leaves are elegant and willowy, and they are traditionally associated with women.

STEP 1

Prepare your materials—paper, brush, paint, and water—and contemplate the image you want to render.

Load the brush with dark green paint, then construct the long green leaves of the plant in "dancing," calligraphic strokes. Make two or three of these strokes representing stems that will support the flowers.

STEP 2

You can render a few flowers on the same stem. Saturate a soft brush with lots of orange paint. Make two strokes in the middle to form the center of the blossom, then add other petals. Add a few more orchid flowers if you wish.

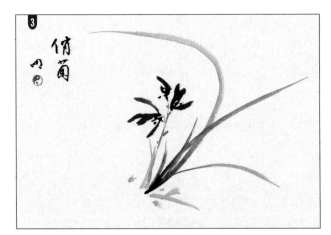

STEP 3

Complete the painting by adding the fine green line for stem. Add the stamens to each flower.

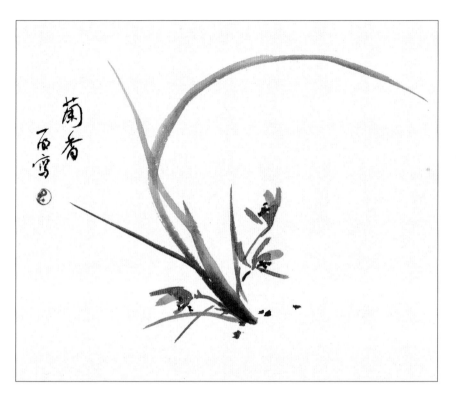

ORCHID VARIATION

A subtle change to the color palette can result in an entirely
different mood. Here, more black was used to prepare the leaf and
stem colors, along with a slightly duller red for the orchid.

Chrysanthemum

In China there are many varieties of this fall flower, which many a poet and painter
has evoked over the centuries in his or her work. Chrysanthemums have
layers of thin petals on the flower head; the leaves are quite untidy looking, with
a big section in the middle and a small one on each side.

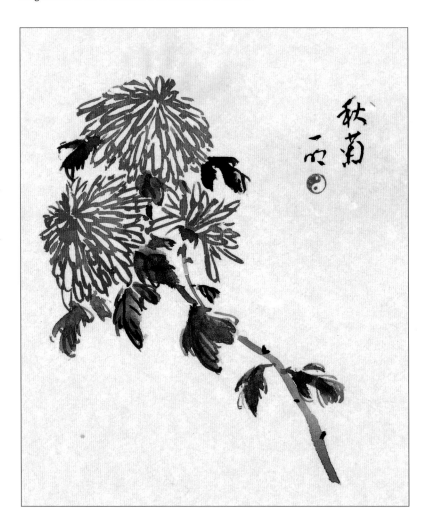

CHRYSANTHEMUM VARIATION

Here is a vibrant painting of the same subject, with good tonal variation in the leaves and stem
and three bright flower heads.

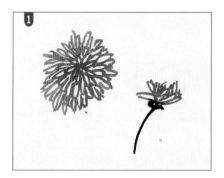

STEP 1

Plan how you want to arrange the flowers in your painting. Load a hard brush with lots of orange paint and begin rendering the first flower; then add another. Some can be depicted small or as buds.

STEP 2

Use a soft brush with plenty of dark green paint and begin rendering to add the leaves around the flowers. When this application is almost dry, add the details of the dark colored veins and the calyxes at the bottom of the flowers.

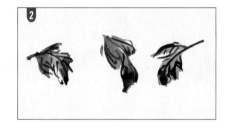

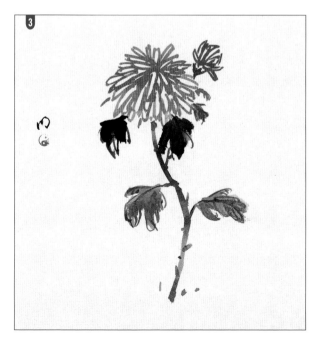

STEP 3

With a hard brush and green paint, add the stems.

Bamboo

Bamboo is tall, strong, and yet supple—standing upright but bending in the wind. It is a year-round plant and is vital to many aspects of Chinese life. It is used in building, for decoration, and for eating utensils, and provides food for China's informal national emblem, the panda.

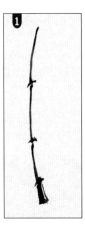

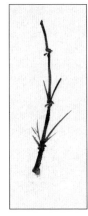

STEP 2

The downward leaves are painted with a soft brush. Saturate the brush with green paint. Start from the stem and drag the brush to the end of each leaf to form a point, just as when you are writing the "duck's tail" in calligraphy.

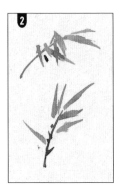

STEP 1

Start from the bottom. With a hard brush loaded with dark green paint, execute the stem in sectional straight strokes. Paint a short stroke across each gap between sections. Each section should be progressively thinner toward the top.

STEP 3

Extra branches will make the painting look more comfortable. Add some small bamboo shoots coming up from the ground.

BAMBOO VARIATION

Here is a solid, aesthetically pleasing motif that would complement many of the Chinese characters shown in the directory, pages 38–223.

画廊

Gallery

Chapter three

Introduction

The seals and calligraphy scrolls displayed here have been chosen to demonstrate the good practice of this ancient, yet still vibrant and expanding, art. The artists are from all over the world—Canada, the United States, Great Britain, China, Hong Kong—where they teach, exhibit, and give lectures to people interested in learning more about, and cultivating the art of Chinese calligraphy.

Scrolls are designed mainly in two styles, horizontal and vertical. Both of these have characters written from the top right column, straight down, and carry on to the next column until the proverb or the poem has ended. The artist's name will be either below the end of the poem or at the column to its left. A name seal underneath the artist's name gives the identification and the copyright to the artist.

▼ *One can be drunk on tea!* Xin Cao Shu (Cursive Script), by Kwan Shut Wong

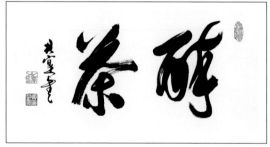

▲ *As if God is helping with my strokes,* Tang dynasty poet Du Fu. Xin Shu (Running Script), by Yat-Ming Cathy Ho

Nowadays, Chinese calligraphy and paintings are exhibited regularly outside of China. Galleries and museums in the world's major cities house a number of valuable Chinese artworks, which give much insight for anyone who wishes to understand the art further. The Gu Gong Museum in Beijing, the National Palace Museum in Taipei, the Victoria and Albert Museum in London, the Metropolitan Museum of Art in New York, and many other wonderful museums and galleries are all worth a visit when you are in the area.

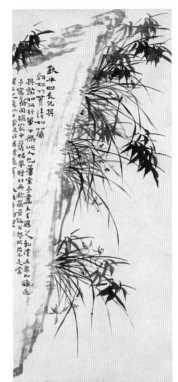

▶ *Orchids, Bamboo, and Rock*, before 1740 by Zheng Xie (1693–1765). Hanging scroll, ink on paper, at The palace Museum, Beijing.

Absorb whatever you can from these examples of beautiful calligraphy. Chinese calligraphy is an art of a lifetime. Perfection does not come easily. Bad strokes (flat ones without "ti" and "dun") and emptiness (without "qi," or spirit) are the main contributing factors to a piece of bad calligraphy. Train your eyes to judge them with what you have learned. Be humble to learn, but critical in your judgment.

We all have different priorities in everything. It doesn't really matter whether one's interest lies in the art of calligraphy, or the love of the language, or simply a desire to learn Chinese. Once you start, you will in time find your way forward to what you want to do next. There is so much for you to explore.

Feng Zi Chan

Feng Zi Chan is a 96-year-old Grand Master in seal engraving and a master calligrapher in Zuan Shu (Seal Script). He is revered as much for his humble and kind nature as for his art. He published *A Collection of Seals* and is presently chairperson of the Chinese Calligraphy and Seal Engraving Society of Vancouver and advises the Ontario Chinese Artist Society, Chinese Canadian Artists' Federation in Vancouver, China Overseas Shoushan Stone Association, and other organizations. There is tremendous pleasure to be found in admiring his engraving technique and the wise words he has chosen for his leisure seals.

◀ Stay safe and healthy year after year.

▼ I please my soul with ink and colors.

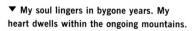
▼ My soul lingers in bygone years. My heart dwells within the ongoing mountains.

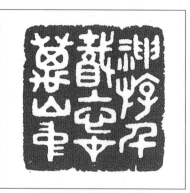

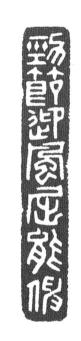

▲ Upright against
the wind yet
bows humbly
when necessary.

求是山人陳風子印集

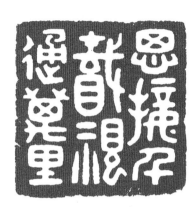

思接千載視通萬里

▲ My mind is linked
with the past thousand
years. The next ten
thousand miles are
in my vision.

◀ With a seal stone
in my hand I can
forget many
hundreds of things.

Wun Lau

When a Chinese calligrapher reaches a certain level of his art, his technique and expressions come together to form wonders. Wun Lau's calligraphy is fun and a pleasure to read. During his lifetime, his love for calligraphy prompted him to become adviser to the Hong Kong Calligraphy Society and Pan Yu Young Calligraphers' Association in China.

◀ *Are you me?*

A poem by a Buddhist monk, Rong Xi Fa Shi, who made fun of his own untidy appearance and forgetfulness.

Xin Shu
(Running Script)

▶ **I do it my way.**

Xin Shu
(Running Script)

Lui Tai

Based in San Francisco, where she joins fellow calligraphers and painters exhibiting in cities across North America, Lui Tai has traveled the world with her brushes for demonstrations and exhibitions. She insists that her students follow the basics in understanding the structure of the characters and learning how to handle the brush.

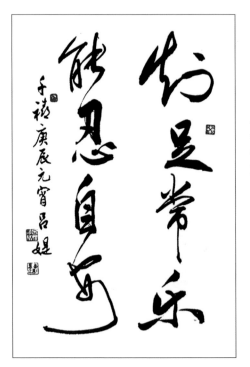

◀ **Contentment is the key to happiness, and endurance can keep worries away.**

Xin Shu (Running Script)

▼ A couplet from the Tang dynasty:

Listen all night to the spring rain at my humble dwelling. Look for buyers for my flowers in the early morning at the long alleyway.

Li Shu (Clerical Script)

Yim Tse

Having studied Chinese calligraphy under Chien Shi Lin, from 1968 until his retirement in 1999, Yim Tse was the Chinese librarian in the Asian Library at the University of British Columbia. He now devotes himself to the study of calligraphy. In 1985 and subsequently in 1995, he curated and participated in Karma of the Brush, a contemporary Chinese Japanese calligraphy exihibition in Vancouver. One of his works has been collected by the Canadian Museum of Civilization.

▶ **Dancing of the crane.**

Xin Shu (Running Script)

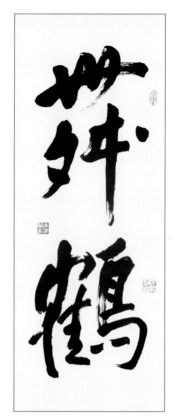

▼ *Zi Gong asked, "Is there a single concept that we can put into practice all our life?" Confucius said, "That would have to be magnanimity: Do nothing to others that you would not want to have done to yourself."*

Xin Shu (Running Script)

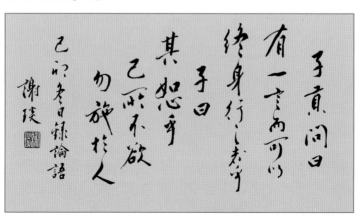

Yat Ngau Lo

Mr. Lo puts his heart, soul, and wisdom into his poetry. He believes strongly that the only path toward becoming a calligrapher lies in rigidly abiding by correct brush techniques and the strict structural rules of calligraphy. He lectures, teaches, and exhibits in China and Hong Kong.

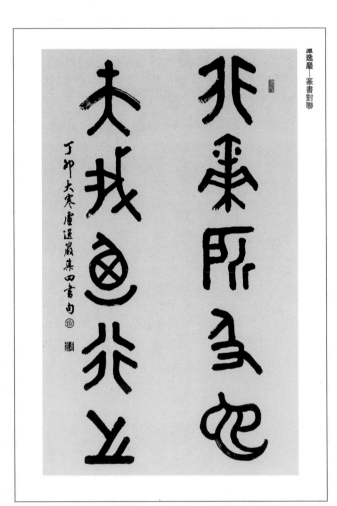

▶ *Li hua ci*
by Han Chang Li

This poem describes the beauty of springtime when all the flowers are busy competing with each other.

盧逸巖—書屈原詩

際會雲龍見幾何千華終古蘊風

波授閒早兮齋三秀不死人仍誦九歌

澤畔末妨庸主棄典墳都是佞臣多

臨江弔處栖栖者騰言題詩吊汨羅

甲申初夏盧逸巖屬堂書屈原一律

◀ *A poem by Qu Yuan*

Xin Shu (Running Script)

Kai Hung Chan

Kai Hung Chan exhibits in Hong Kong and Texas. He is vice chairman of the Texas Chinese Arts Society.

Yuk Man Lai

An accomplished artist in Chinese calligraphy and painting, Yuk Man Lai's work has been collected by the Hong Kong Museum of Art and the Shenzhen Museum of China. He is the proprietor of C.C. Arts Gallery in Vancouver, Canada.

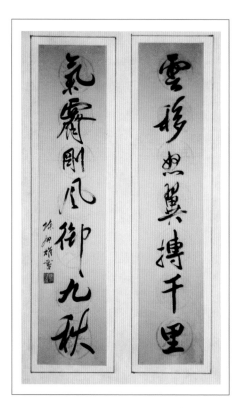

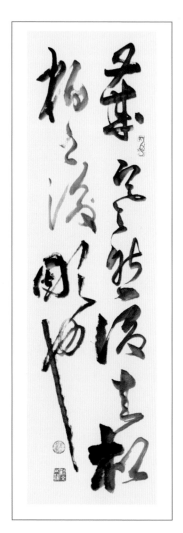

▲ *Clouds stretch their wings angrily over thousands of miles. The current and wind rule over nine falls.*

A couplet: Xin Shu (Running Script)

▶ *Only after the cold winter arrives do we become aware that pine and cypress trees are the last to wither away.*

Cao Shu (Cursive Script)

Kwan Shut Wong

A professional in Chinese painting and calligraphy Kwan Shut Wong has worked at Christie's New York for more than two decades. An artist and scholar, he has studied numerous pieces of ancient and modern Chinese calligraphy. His love for the art started long before his first job at Hong Kong Chinese University in 1962. He believes that calligraphy should encompass "strokes both angular and smooth, tradition before modernity, without vulgarity beneath the brush, and, in the end left to tien (God)."

▶ *The Beigu Pavilion*

A ci poem by Xin Qiji

Cao Shu (Cursive Script)

▼ *One can be drunk on tea!*

Cao Shu (Cursive Script)

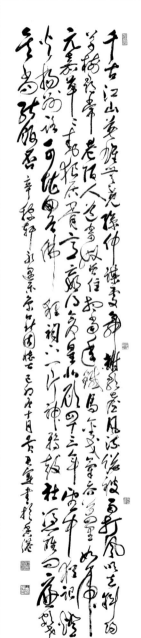

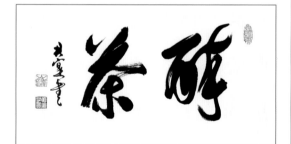

Yat-Ming Cathy Ho

Born in Cheng Dou in Sichuan Province, Yat-Ming Cathy Ho studied calligraphy under Chien Shi Lin who was a phenomenal artist in Chinese calligraphy, painting, poetry, and seal making in Hong Kong. Yat-Ming has held exhibitions in Hong Kong, London, Manchester, Liverpool, and the Wirral and has given talks and demonstrations at museums and galleries all over England and Scotland.

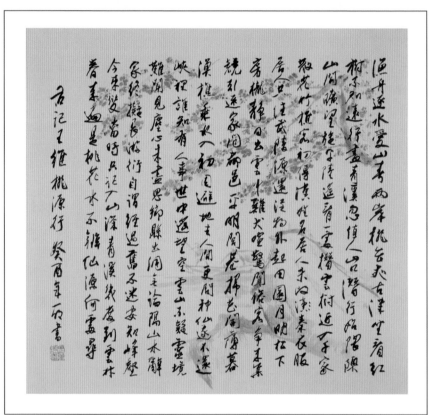

▶ *Peach Blossom Stream.*

Tang poem by
Wei Wang.

The poem describes an ancient village hiding away from war, which was found by a fisherman.

Xin Shu (Running Script)

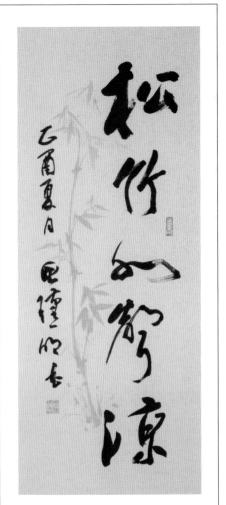

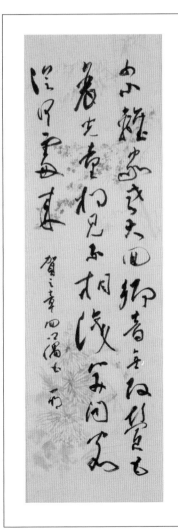

◀ *One feels cool listening to the drizzling of the stream in the presence of fir trees and bamboo.*

Xin Shu (Running Script)

▶ A Tang dynasty poem by Zhi Zhang.

The poem describes the sadness he felt when returning home after years away. His reputation was unchanged, but his hair had gone gray. A smiling child asked him where he was from.

Xin Shu (Running Script)

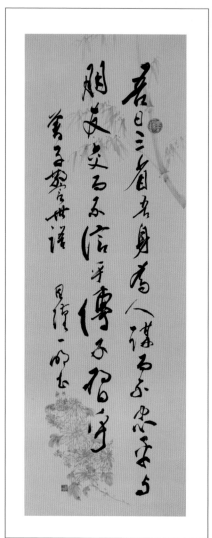

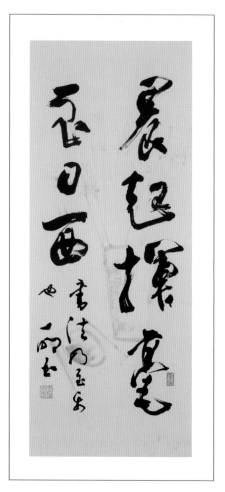

◀ *Self-review three times a day.*

Wisdom from Ceng Zi

Xin Shu (Running Script)

▶ *I write until the sun sets.*

Xin Shu
(Running Script)

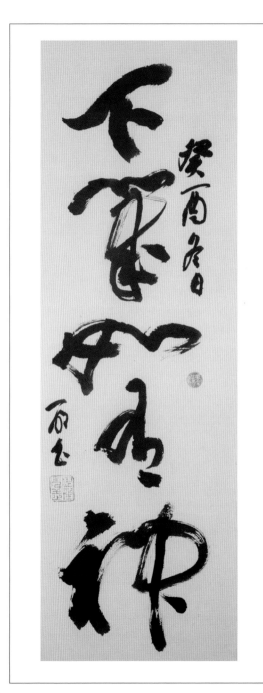

◀ *As if God is helping me with my strokes.*

Tang Dynasty poet Du Fu.

Xin Shu (Running Script)

Resources

UNITED STATES
Dick Blick Art Materials
PO Box 1267
Galesburg, IL 61402–1267
General info: (800) 933 2542
info@dickblick.com
International: (309) 343
 6181
international@dickblick.com
www.dickblick.com

Jerry's Artarama
5325 Departure Drive
Raleigh, NC 27616
(800) 827 8478
www.jerrysartarama.com

Oriental Art Supply
21522 Surveyor Circle
Huntington Beach, CA 92646,
phone: 714 969 4470 or
(800) 969 4471
fax: (714) 969 5897
email: info@orientalartsupply.
com

Asian Brush Art and Graphic
Design
508 Arrowhead Dr.
Greensboro, NC 27410
(336) 793 0015
www.asianbrushart.com

UNITED KINGDOM
Louisa S.L. Yuen
Oriental Arts
5 Gardner Street
Brighton
East Sussex BN1 1UP
(01273) 819 168
louisayuen1000@yahoo.co.uk

Guanghwa Company
7–9 Newport Place
Chinatown
London WC2H 7JR
(020) 7437 3737
customers@guanghwa.com
www.guanghwa.com

Ying Hwa Co. Ltd
14 Gerrard Street
London W1D 5PT
(020) 7439 8825

AUSTRALIA
Art Requirements
1 Dickson Street
Wooloowin, QLD 4030
(07) 3857 2732

Eckersley's
97 Franklin Street
Melbourne, VIC 3000
(03) 9663 6799
art@eckersleys.com.au
www.eckersleys.com.au

HONG KONG
Man Luen Choon
International Supplies
2nd Floor, Harvest Building
29–35 Wing Kut Street
(852) 2544 6965
art@manluenchoon.com
www.manluenchoon.com

Index

Y

Z

Credits

Quarto would like to thank the contributing artists for kindly submitting work for inclusion in this book. All artists are acknowledged beside their work.

Quarto would also like to acknowledge the following:

Key = a above, b below, l left, r right

p10 Dean Conger/Corbis
p11b Bob Krist/Corbis
p14al Royal Ontario Museum/Corbis
p14ar Royal Ontario Museum/Corbis
p14br Yat Tak Ho

All other images are the copyright of Quarto Publishing plc. While every effort has been made to credit contributors, Quarto would like to apologize should there have been any omissions or errors—and would be pleased to make the appropriate correction for future editions of the book.

Author's acknowledgment

I am forever grateful to my late calligraphy teacher Lin Chien Shih for his gifted intelligence and guidance. I would also like to thank my dear friends and calligraphers who allowed me to display their beautiful calligraphy scrolls in the Gallery section. I hope the readers will find this book useful in introducing you to the art of Chinese calligraphy.

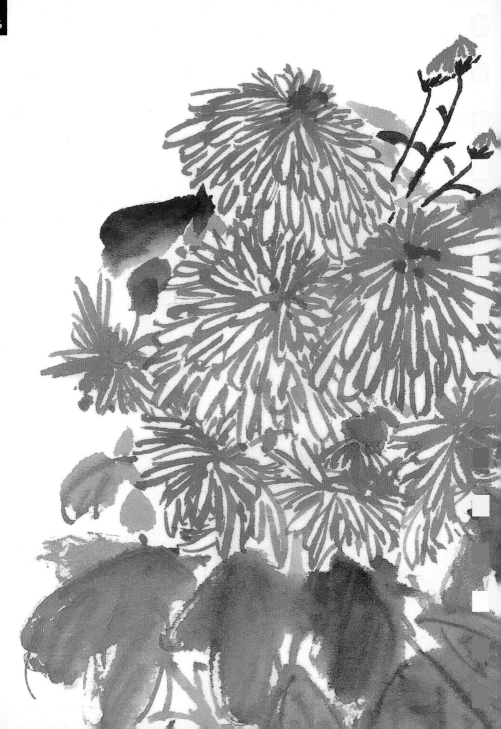